IMAGES

of America

BLAIRSTOWN

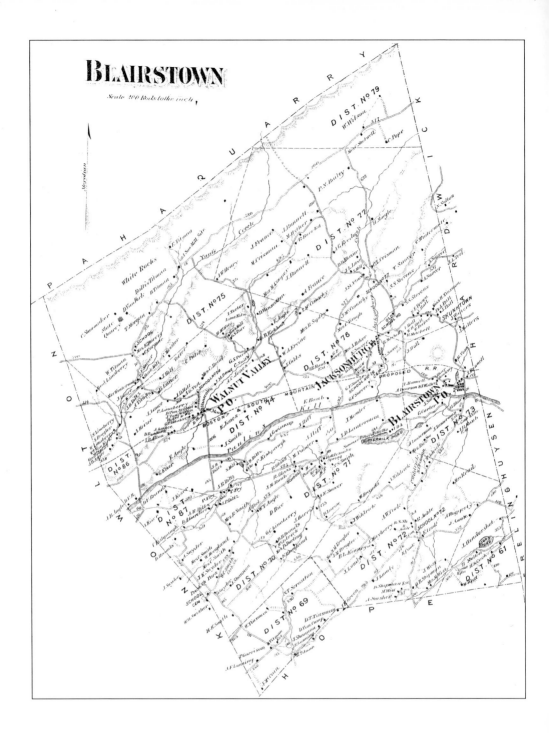

BLAIRSTOWN

Scale 200 Rods to the inch

IMAGES
of America

BLAIRSTOWN

Kenneth Bertholf Jr.

ARCADIA

Published by Arcadia Publishing,
an imprint of Tempus Publishing, Inc.
2 Cumberland Street
Charleston, SC 29401

Printed in Great Britain.

Library of Congress Catalog Card Number applied for.

For all general information contact Arcadia Publishing at:
Telephone 843-853-2070
Fax 843-853-0044
E-Mail arcadia@charleston.net

For customer service and orders:
Toll-Free 1-888-313-BOOK

Visit us on the internet at http://www.arcadiaimages.com

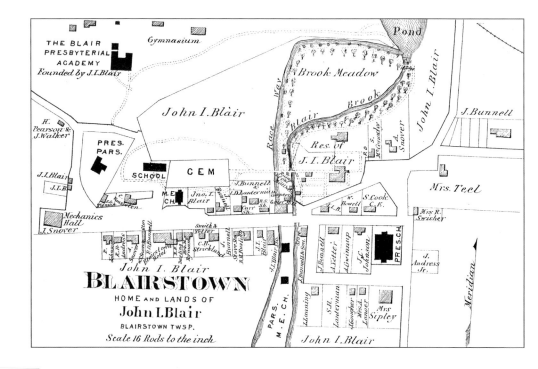

CONTENTS

ACKNOWLEDGMENTS

Without the following people being involved behind the scenes, this book may not have come to print:

A special thank you to Nancy Radwin and Lianne Tucker Markus, for they have been my support throughout the stages of putting this book together. They have spent countless hours whenever I would call for help. Just think, Nancy, it all started by having "Blairstown's History" within *The Knowlton News*.

The following were kind enough to lend photographs or postcards from their collections: Sara Kitchen, for her help on chapter 8, titled "Neighbors"; Wayne McCabe, for his expertise on his railroad photographs; Monie Hardwick of Blair Academy, for taking the time to find that great photograph of John I. Blair; the Catherine Dickson Hofman Library; the Blairstown Fire Company; and the Blairstown Ambulance Corps. for their photographs.

INTRODUCTION

Blairstown, New Jersey, one of the northern townships of Warren County, was established from a portion of Knowlton Township by an act of the New Jersey State Legislature in February of 1845. The town, so named in honor of John I. Blair, one of its most prominent citizens, embraces 27.30 square miles, or 17,472 acres of land. It is bound on the east by Hardwick and Frelinghuysen Townships, on the south by Hope, the west by Knowlton, and the north by Pahaquarry Township, which merged with Hardwick in 1997.

Blairstown lies along the summit of the Blue Mountains and from that point to the valley of the Paulinskill, it is a succession of rolling hills. Referred to as the "Gem of the Paulinskill," Blairstown is romantically situated on the banks of this stream, 9 miles from its confluence with the Delaware River, 13 miles from Newton, New Jersey, the county seat of Sussex County, and 15 miles north of Belvidere, New Jersey, the seat of justice for Warren County.

Although Paulinskill is the principal body of water, there are other water courses throughout the township including the Jacksonburg, Walnut, Yards, Dilts, and Blair Creeks. Cedar Lake, once a popular summer resort, still remains a natural, tranquil part of Blairstown.

The exact date of Blairstown's settlement by civilized man will probably never be known, but there can be no doubt about its being among the earlier settlements within the limits of Warren County.

The original name for the area was Smith's Mills. Many years before the Revolutionary War, a man of that familiar name had a large gristmill on Main Street next to Blair Lake. In later years, nearly all the land within the town limits was owned by Jacob Buttz, or Butts, as the name was then spelled. Butts had a bridge across the Paulinskill, and so the area was known as Butts Bridge. After Butts Bridge, the town was briefly named Gravel Hill. Then, at a public meeting in 1839, the name of Gravel Hill was changed to Blairstown, in honor of John I. Blair.

Immediately after this large and respectable meeting, a communication was sent to the postmaster general in Washington, D.C., and on February 4, 1839, the Gravel Hill Post Office sign was replaced with Blairstown.

The progress of the village was gradual but continuous with the help of John I. Blair, a railroad forerunner and wealthy businessman of the time. Probably his most significant contribution to the development of Blairstown were his efforts to bring the railroad lines through the township. This progressive move brought an influx of businesses and families to the area.

People make a community. The first chapter, "Home Is Where the Heart Is," depicts leaders,

volunteers, and prominent families who contributed to the growth and development of Blairstown.

Readers will visit the valleys, mountains, and rolling hills of Blairstown. Photographs of the Paulinskill, Cedar Lake, and its many country creeks appear. The pages are filled with historical facts captured in print. Enjoy "Faith and Knowledge," a chapter dedicated to the churches and schools, and "Getting on Track," a section of postcards depicting the construction of the railroad lines.

To represent the business community, the chapter "A Time for Work" has been created, and for the recreational and inherently beautiful sites, "A Time for Play" follows.

The chapter "Volunteers and Valiant Efforts" contains images of the men and women who gave time to community service. "Early Events" takes you through community celebrations and newsworthy affairs. In the final chapter, "Neighbors," one can see how closely knit the surrounding communities of Delaware, Columbia, Hainesburg, Vail, and Hope have always been to Blairstown.

Dedicated to my wife, Bonnie,
and my daughters, Kimberly and Nicole,
who for the past many years have shared
my many trips searching for local history
on our town called Blairstown.

One

HOME IS WHERE THE HEART IS

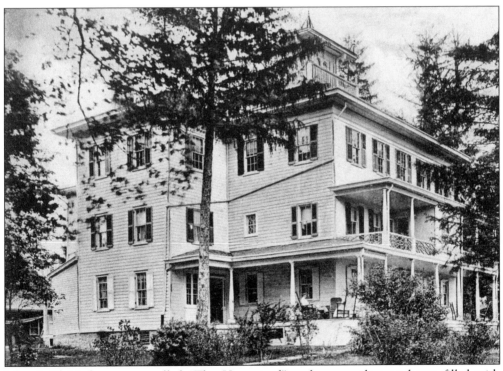

John I. Blair's home was called "The Homestead" and was a pleasant home filled with hospitality and comfort. The Blairs raised four children in this great home. They were DeWitt Clinton Blair, Marcus L. Blair, Emma E. Blair Scribner, and Aurelia A. Blair Mitchell.

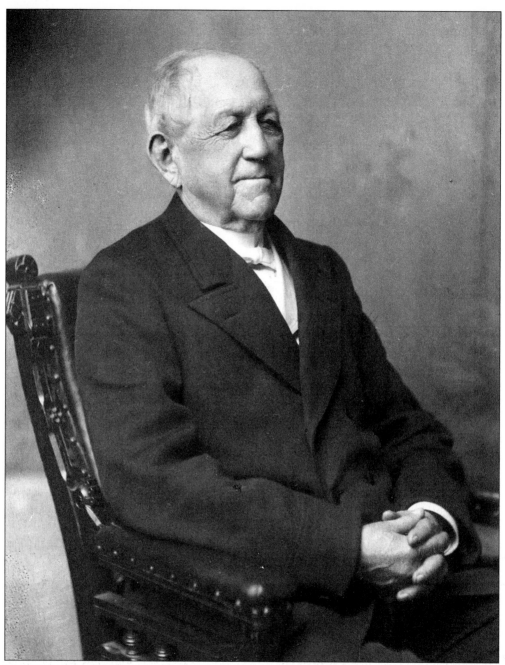

The Hon. John I. Blair was born on the banks of the Delaware River, near Belvidere, New Jersey, on August 22, 1802. The life of John I. Blair is a striking example of how many great things can be accomplished by the youth of the country, even in the absence of academic or collegiate instruction, through the exercise of industry, perseverance, and integrity in business life. It would be beyond the scope and limits of a work of this kind to pursue in greater detail the various railroad and business enterprises of Mr. Blair, who was one of the railroad magnates of America and controlling owner of many corporations. Mr. Blair passed away on December 3, 1899, and is buried on the hillside behind the mill located on Main Street.

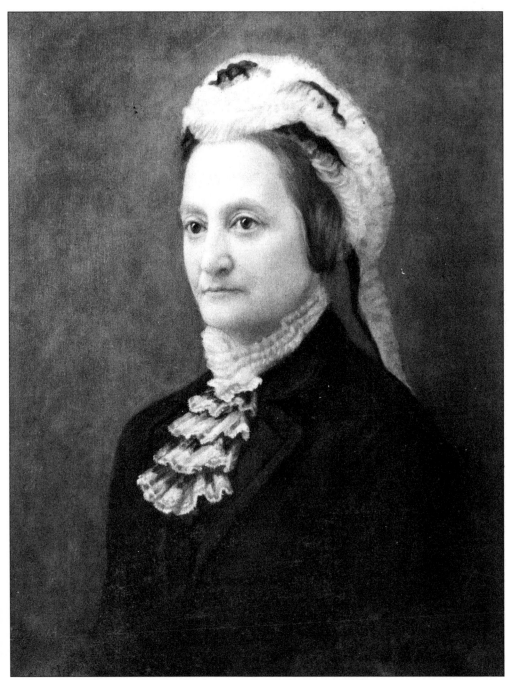

Ann Locke was born on November 13, 1804, the daughter of John Locke of Frelinghuysen Township, New Jersey, and granddaughter of a Revolutionary patriot, Capt. Locke, who lost his life in the struggle for national independence at the Battle of Springfield, New Jersey. Ann Locke became Ann Locke Blair on September 27, 1827. Mrs. Blair is most remembered for her kindness in helping the poor and needy in her town. She died on October 12, 1888, and is buried next to her husband at the old cemetery on the hill.

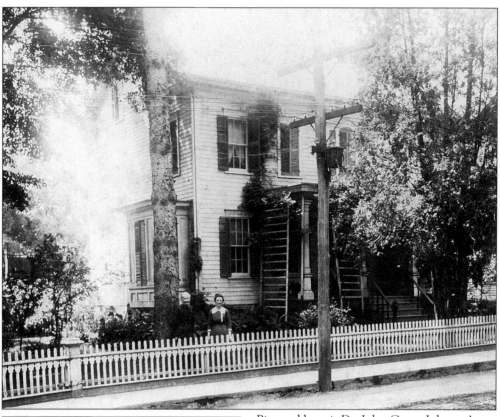

Pictured here is Dr. John Couse Johnson's homestead, located on what is now called Main Street. Dr. Johnson came to Blairstown in 1850, and, at that time, had 24 dwellings, one store, one hotel, a few machine shops, a carriage factory, and two churches.

Dr. John Couse Johnson was born in Wantage Township, Sussex County, on October 21, 1828. Upon receiving his certificate from the College of Physicians and Surgeons at New York in 1850, he came to Blairstown and married Miss Ann Howell in 1862. He served as president of the New Jersey State Medical Society in 1867 and president of the Warren County Medical Society from 1862 to 1864. This beloved physician died December 23, 1907. The community still speaks of him with the highest respect. His long arduous tasks were completed with great skill.

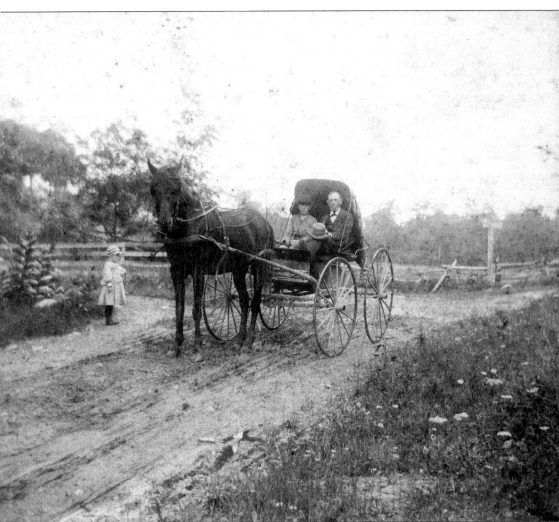

Dr. Johnson made many trips over the Blue Mountain Ridge that took him to the Delaware River. He often stopped at the home of Malachi Sutton, a settler in Pahaquarry Township. Mr. Sutton would give him a fresh horse to continue his journey as well as a strengthening meal to sustain the doctor until his return to Blairstown late at night. His country practice was extensive, but he had time to contribute articles to the State Medical Society and various medical papers.

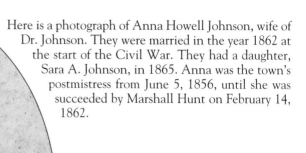

Here is a photograph of Anna Howell Johnson, wife of Dr. Johnson. They were married in the year 1862 at the start of the Civil War. They had a daughter, Sara A. Johnson, in 1865. Anna was the town's postmistress from June 5, 1856, until she was succeeded by Marshall Hunt on February 14, 1862.

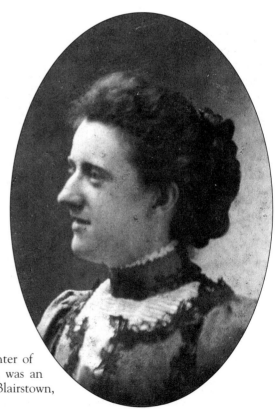

Sara A. Johnson (1865–1934), the daughter of Dr. John C. and Anna Howell Johnson, was an organist in the First Presbyterian Church, Blairstown, for a quarter of a century.

This is the home of the McCrackens. The porches were added around 1902. To the left you can see the old machinery repair shop. The firehouse is to the left behind the old machinery shop.

Here Mr. McCracken is seen standing on the porch of a store on Main Street.

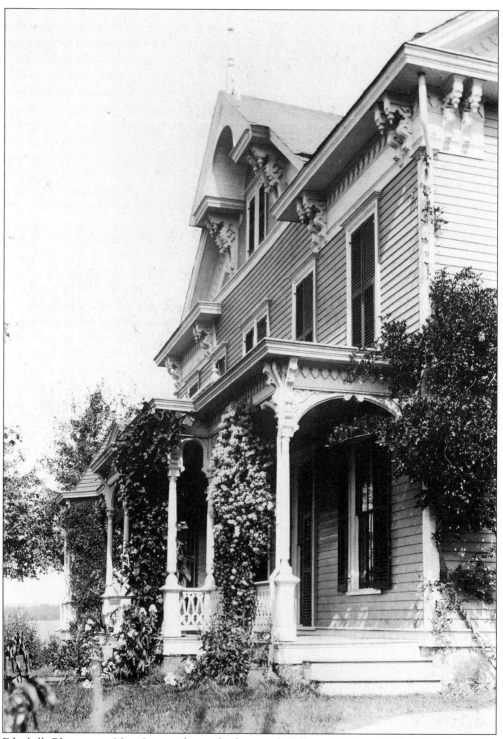

Edgehill, Blairstown, New Jersey, shows the home of William C. Howell. Mr. Howell was the first president of the National Bank of Blairstown and served in this position for 22 years. The first day's business deposits totalled $5,628.88.

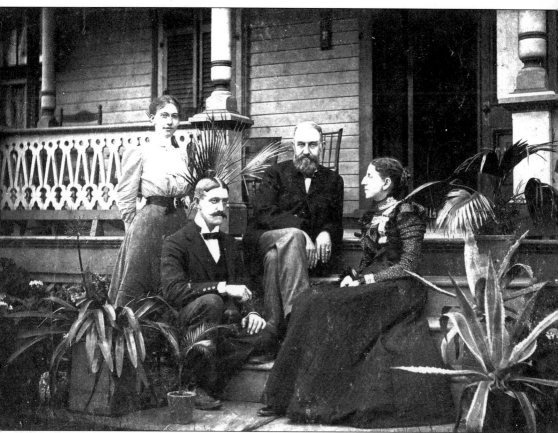

This photograph shows the Howell family on the porch of their Edgehill home around 1898. Shown here are William C. Howell (1843–1922), Henrietta Parsons Howell (1840–1931), Robert Parsons Howell (1873–1920), and Elizabeth Howell Wilkins (1872–unknown).

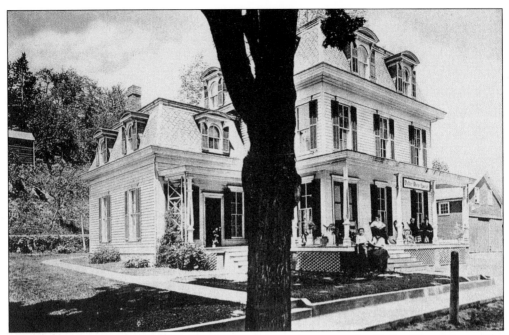

In 1868, John Bunnell built a boarding house that was known as the Valley View House. The following year, the Freeholders met at this residence to further plans for reconstructing High Street so dwellings could be built on both sides of the street.

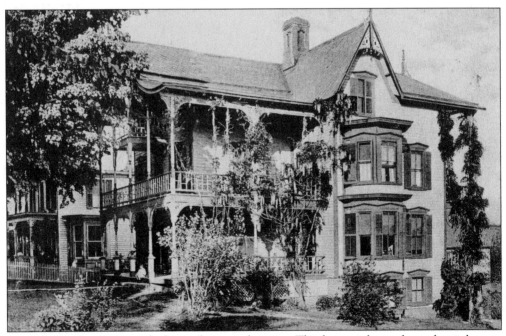

In 1917, Dr. Gordon started a home for convalescents. This home is located on what is known as High Street.

18

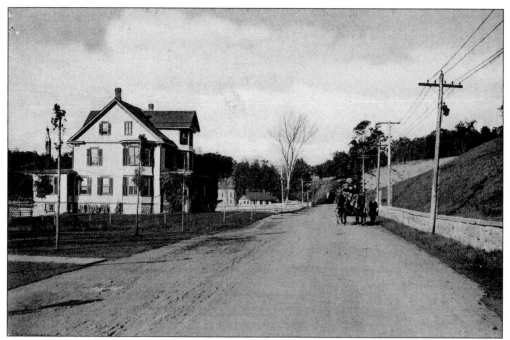

Pictured here is the home of John F. Bunnell in 1910 looking out on Park Street from the present entrance to Blair Academy. J.F. Bunnell had a large and successful carriage manufacturing business and was a ruling elder in the Presbyterian church at Blairstown. Also, J.F. was one of the first to urge the importance of building an academy. Without his earnest advocacy, it is doubtful the school would have been established.

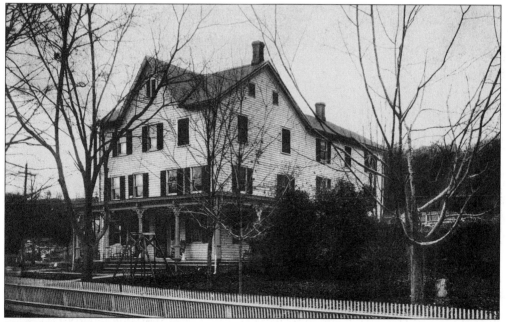

This is the Cedar Lake Cottage home that was located on Cedar Lake Road. It was the main home of the Cedar Lake House owners. Many people from Philadelphia occupied the house as boarders during the summer months.

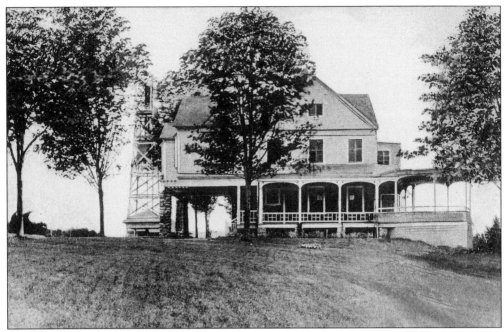

This is a photograph of Bonnie View, the estate of the Heller family atop Heller's Hill. The Heller family lived in Newark and used this country-style house as their summer residence. Take notice of the windmill that ran the well.

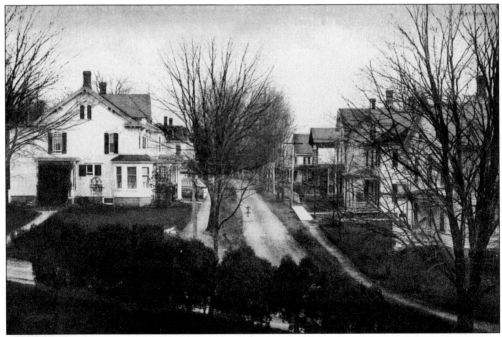

This is a northern view of High Street, then a dirt road. The Valley View Home on the left housed many boarders.

Two

FAITH AND KNOWLEDGE

In 1839, plans for building the
First Presbyterian Church were
reviewed. The church was built in
1840 and a 218-pound bell pealed
throughout the valley, inviting all
to come and worship. This church
was a stone building, 49 by 50 feet,
with a belfry and spire. It seated
200 people. The cost of the
building was $2,865.98. Rev.
Condit gave the dedication on
December 10, 1840. The First
Presbyterian Church eventually
needed to be replaced. The present
church was dedicated on February
15, 1872. The new church, like
the old one, was built of limestone.
It is 80 by 53 feet and seats up to
500. When installing the steeple,
the workers had to use jack screws
since it consisted of 8 pieces that
were each 72 feet long. The new
bell weighed one ton and cost
$950. It was transported to
Blairstown by ox cart from
Portland, Pennsylvania, and
people lined the road to watch its
journey.

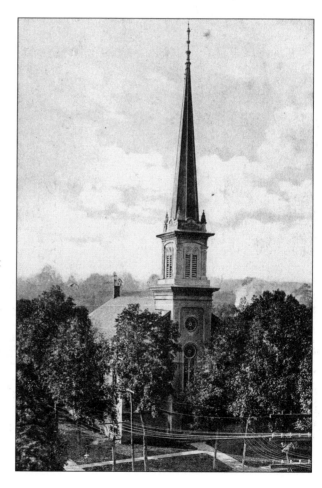

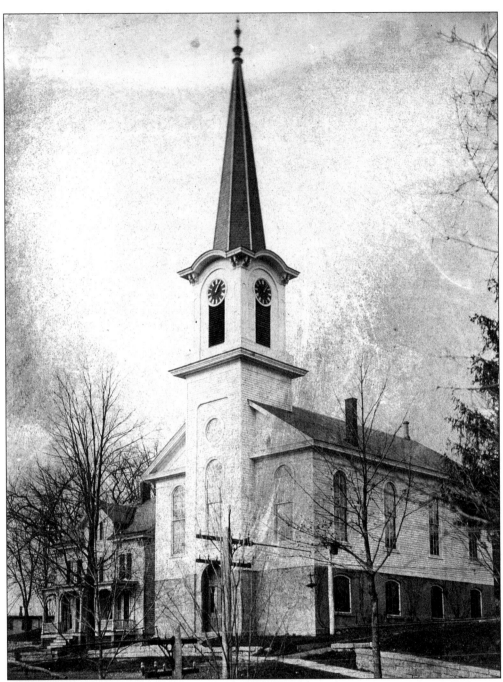

John I. Blair, a steadfast Presbyterian, donated land on the hill, opposite today's post office, to the Methodists in 1838. The church was a plain stone structure, 34 by 45 feet, with no spire or belfry. By 1873, it was so dilapidated the congregation felt a new one was needed. The new building was dedicated on January 23, 1875, at a cost of $7,400. A clock was installed within the belfry of the church when it was built. For years the town clock, as it was called, gave people the time, and the tall spire of the Methodist church, standing out against the hills, was the first view of Blairstown that travelers saw when coming from Newton.

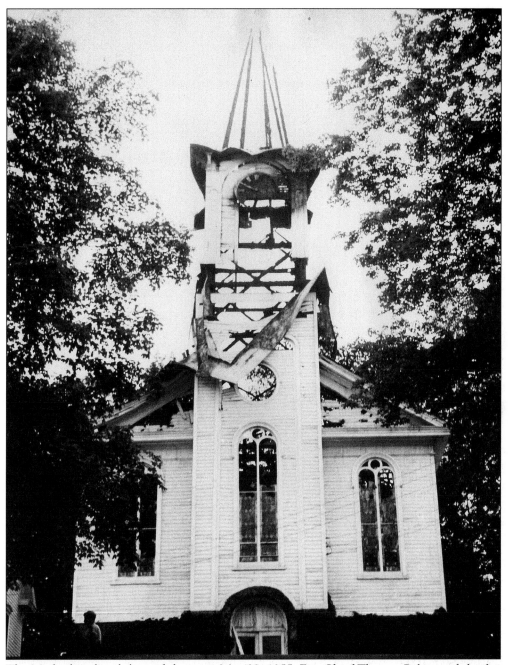

The Methodist church burned down on May 22, 1955. Fire Chief Thomas Babitt said the fire probably started in the rear of the building. By the time firefighters arrived, the blaze had broken out through the steeple. The faithful old town clock had stopped at 10 o'clock and crashed when the steeple fell into a sea of flames.

On April 6, 1848, at a public meeting held in the First Presbyterian Church, Blairstown, a building committee, consisting of Peter Lanterman, John Bunnell, Dr. I.W. Condit, John Hull, John Konkle, John I. Blair, and John Messler, was appointed to supervise the construction of a two-story frame or stone academy, on a site offered for that purpose by John I. Blair. The opening of the school was remarkably well patronized. Students coming from a distance obtained board in the school. From the outset, it was a religious school. Apart from its religious character, the school was efficiently conducted, and well deserved the liberal support it received, which greatly contributed to what has been accomplished in subsequent years.

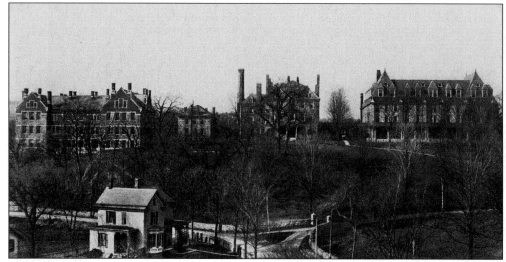

This photograph shows the gateway to Blair Academy. The academy has grown from one building to the many seen by the end of the 1800s. At this time the academy had 43 male and 29 female students, 51 of whom were boarders. The school had already established its tradition of including students from all the states and many foreign countries.

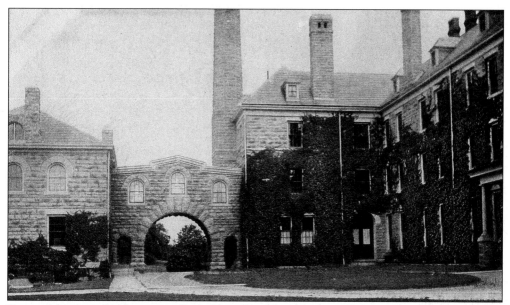

Pictured here is the famous arch at Blair Academy. Even today it is custom to have the graduating class file through the archway to meet the challenges of the world.

This is East Hall at Blair where young minds are prepared for the college or business life. Reading, spelling, penmanship, grammar, geography, and mathematics are taught to advance a student during their life.

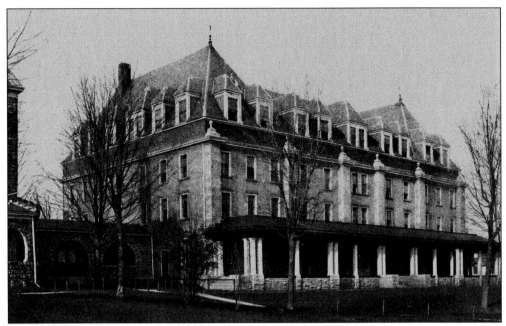

This building was a gift from John I. Blair and was named after his mother, hence the name Insley Hall.

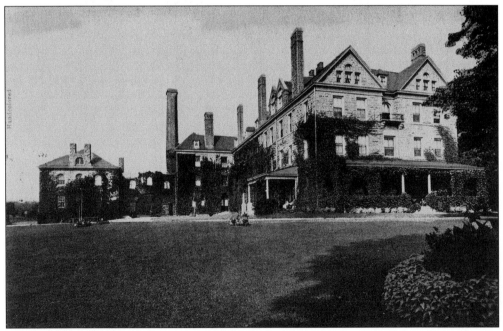

This building was also a gift from Mr. Blair and was named Locke Hall after his beloved wife, Ann Locke Blair.

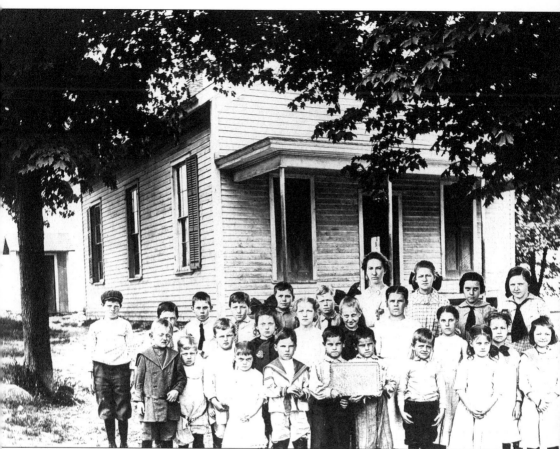

Pictured here is the Walnut Valley School with the sign reading "Walnut Valley, May 21, 1914." This is where students learned the three R's. Walnut Valley, located near the mouth of Walnut Creek, was named for the large number of black walnut trees once growing in that vicinity. In 1812, when black walnut lumber was in high demand for the manufacture of gunstocks, this valley was stripped of its noble black walnut trees and the lumber made from them was converted into gunstocks for the American Army.

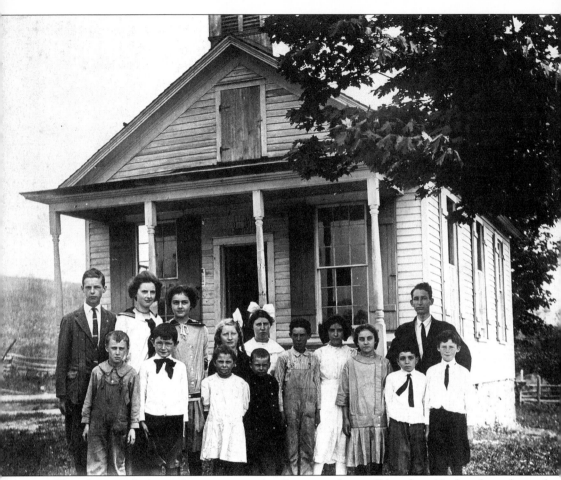

This photograph shows the one-room schoolhouse in the small hamlet of Jacksonburg, located in the narrow valley of Jacksonburg Creek, one mile northwest from Blairstown in School District No. 76. This place was settled as early as 1800 by Joseph and Zebedee Stout. At one time, considerable business was done here. They had a blacksmith and wheelwright shop, store, and about 20 dwellings. There was also a gristmill owned by Samuel McConachy, and a distillery operated by I.F. Read.

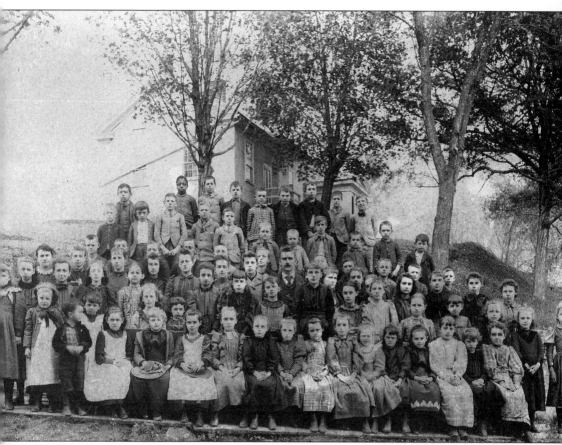

In 1867, a State Free School law was passed and a separate public school, with Miss Lucy Hinds as teacher, was organized in the room of the old music hall at Blair. From 1867 until 1896, the public school bell rang out on "The Hill" to call the children of the village. But as classes grew larger, it was necessary to find larger quarters, and in 1896 the school at the end of East Avenue was built. This picture shows one of the last classes held in the old music hall school. The building belonged to Blair, and Blairstown was the only district in the state that did not own its own school building.

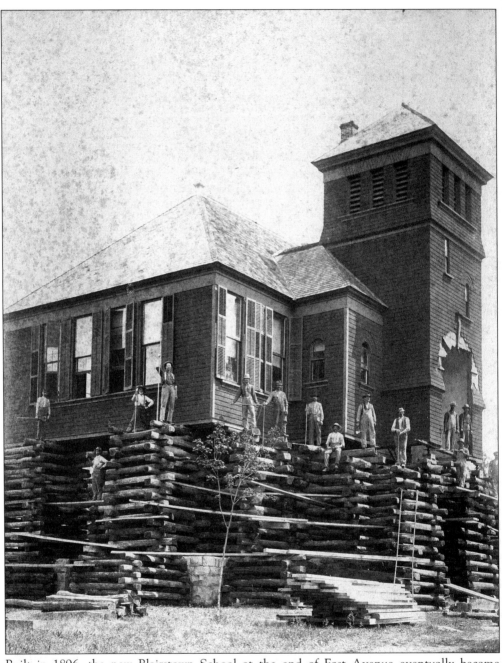

Built in 1896, the new Blairstown School at the end of East Avenue eventually became overcrowded. When a new addition was needed, they didn't spread out far and wide—instead, the building was propped up on railroad ties and two more rooms slid underneath.

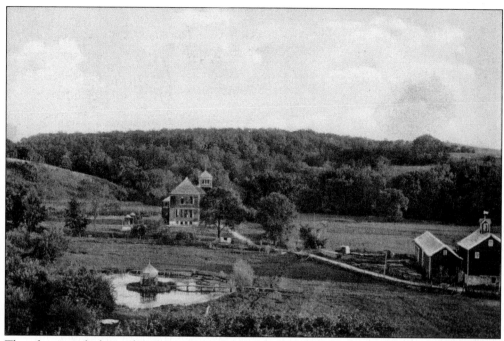

This photograph shows the Blairstown School after the addition was completed. Look closely at the road. Children had to wade to school so often that the road was called Mud Alley, a name that persists even though its official title is East Avenue.

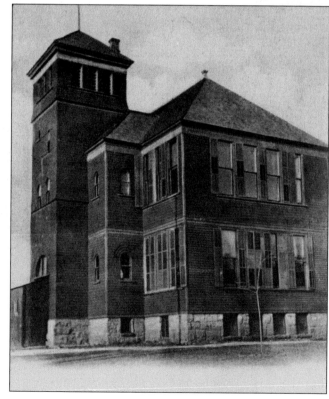

Pictured here is Blairstown Public School around 1907. In 1910, the board of education felt the town should have a three- or even four-year high school course, which necessitated further additions to the building. Emotions ran high and angry discussions took place. Blairstown never saw such a contest and hopes never to see another of equal bitterness. Finally, in 1912, alterations were made to accommodate the increasing number of pupils. During the summer of 1928, the school building burned to the ground and sessions were held for one year at the Cedar Lake House. Through the generosity of Mrs. John D. Vail, additional land was given for the athletic field and the new school building was opened for use in the fall of 1930.

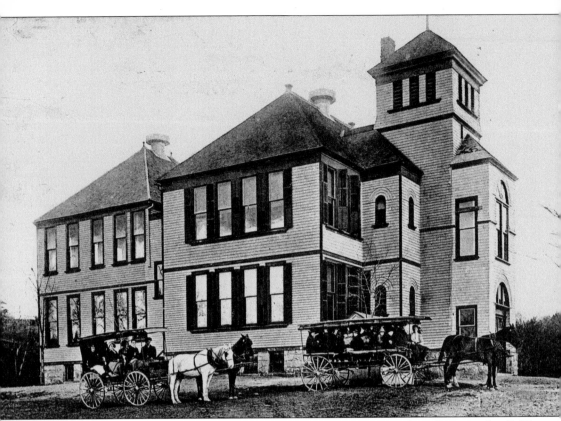

How would you like to be picked up in a horse-drawn wagon to be taken to school? This photograph shows Blairstown High School around 1914.

Three
GETTING ON TRACK

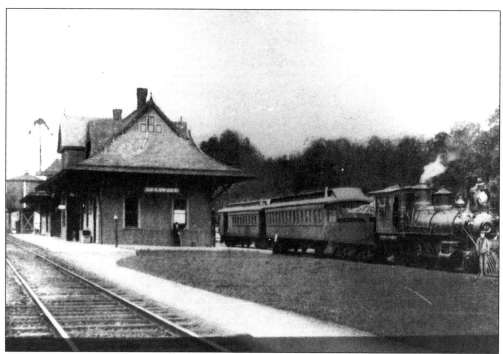

In 1876, Blairstown citizens held a meeting to encourage the building of a railroad from Blairstown to Delaware. A committee was appointed to secure the right-of-way. By July 4, 1876, ground was broken at the culvert near Footbridge Park. That same day in 1877, the train made its first regular trip and citizens were given free rides. The above photograph shows the train widely known as "The Blairstown." Sometimes the residents would call it the "Dinkey." The Blairstown was a wood-burning locomotive and weighed about 16 tons. The cost of this locomotive was $6,000 in 1877.

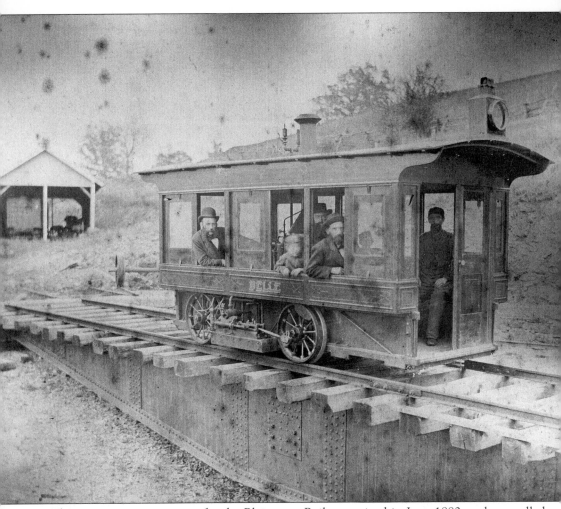

The pony inspection engine for the Blairstown Railway arrived in June 1880, and was called "Belle." It could carry six to eight people on the run between Blairstown and Delaware. It soon earned the name "Dinkey" as a term of affection and amusement for the small engine and car combination. It was unlike anything ever seen by local inhabitants. This photograph shows "Belle" on the turntable by Edgehill. The passengers are John D. Vail, in the rear window; four-year-old Robert Parsons Howell, looking out the window with his father, William C. Howell; Johnny Bartow, in the front window (the engineer on Dinkey); Dave Sliker, seen through the door (the fireman on Dinkey); and Bert Sliker, the little boy in the far corner. This dummy "Belle" was named for Belle Scribner Fitzhugh.

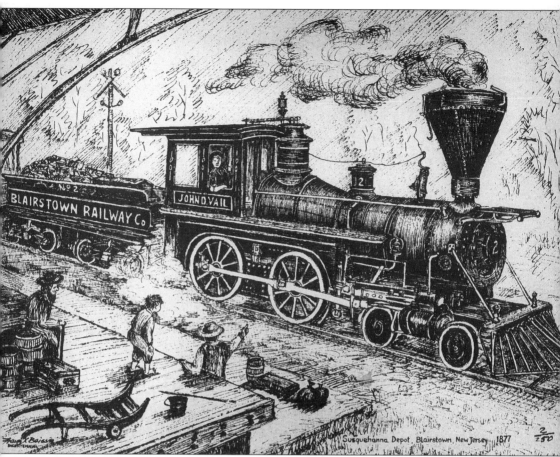

The "John D. Vail" was the second and last locomotive purchased by the Blairstown Railway. It was named for John I. Blair's nephew, and younger brother of Charles E. Vail, Esq., who was Mr. Blair's secretary and right-hand man. Mr. Vail worked his way up through the railroad business and became superintendent and a director of the Blairstown Railway when it was formed and served until it was absorbed into the New York, Susquehanna and Western Railroad (the NYS&W). The engine was a wood-burning American type and weighed 15 tons. The cost of the "John D. Vail" was $3,500 in 1879.

Here we find the surveying crew taking time to pose for a photograph with the camp cook. They had the luxury of staying in the train car.

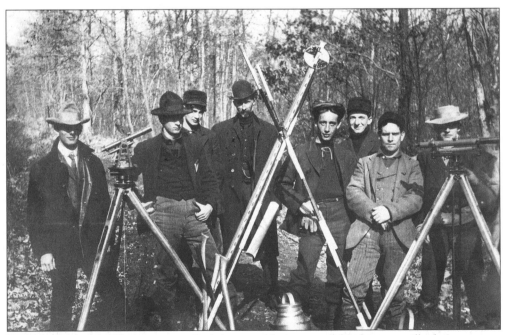

In the backwoods of Blairstown, we find the crew blazing a trail for the new railbed. As you can see, they were very proud of the equipment they used in the field. The instrument on the right is known as a "dumpy level" and had a range of one quarter of a mile. The long sticks, called target rods, were used with this level.

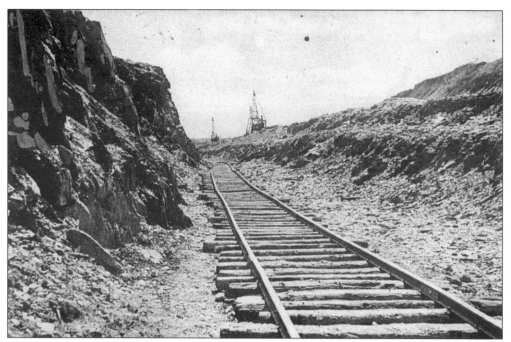

This picture shows the amount of rock that needed to be removed for the Lackawanna cut-off near Blairstown.

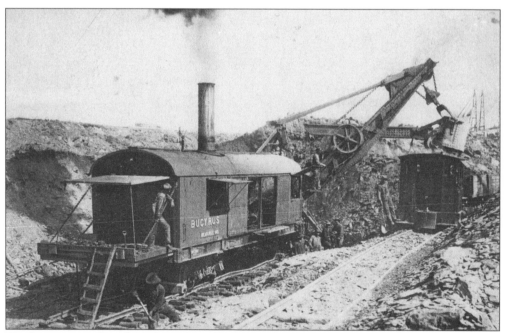

The huge steam shovel on the rail tracks worked the stone, which was then taken to a stone crusher. The resulting material was used to make the bed for the railway. This photograph was taken near Vail.

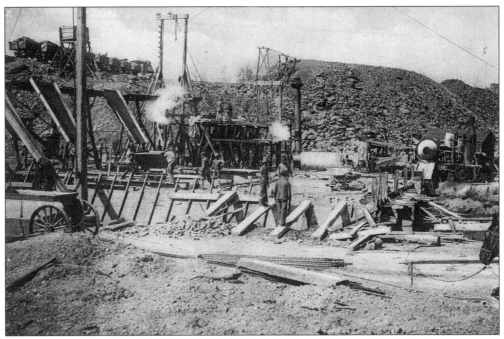

A number of men are shown here at work on the culvert construction for the Lackawanna cut-off near Blairstown.

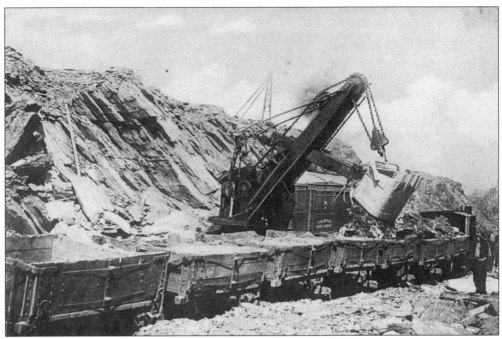

The steam shovel filled the many carts on their way to the crusher. This photograph was taken at the rock cut near Blairstown.

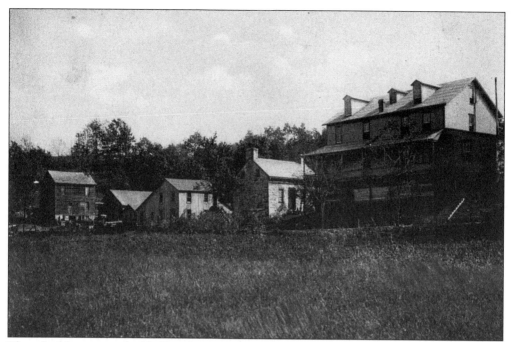

These buildings were the Vail headquarters of Reiter, Curtis & Hill, general contractors for the railroad construction. Many workers were housed here while they completed the Lackawanna cut-off.

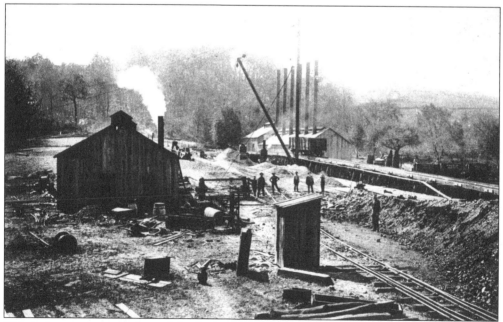

This is the contractor's plant of the Lackawanna cut-off near Vail. All repair work needed on the equipment was done here.

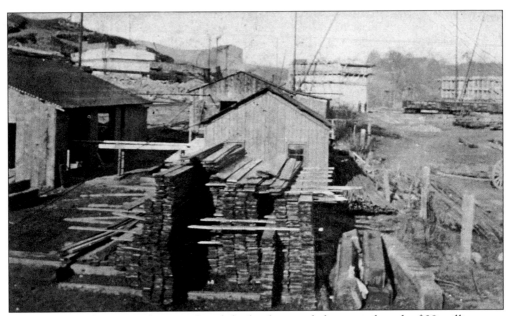

The lumber yard at Hainesburg produced the lumber needed to complete the $29 million cut-off of the Lackawanna.

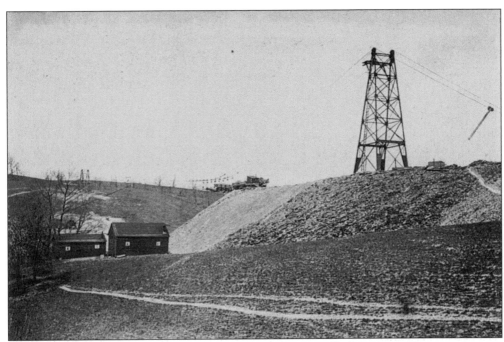

Steel towers and a cable system were used to fill the cut-off's low spots. This was done to maintain a 2 percent or less grade level over the entire railbed.

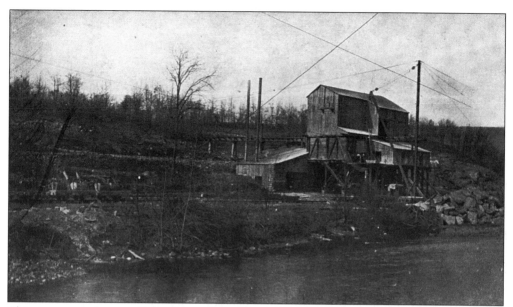

This stone crusher at Hainesburg along the Paulinskill produced base material for the Delaware, Lackawanna and Western Railroad cut-off.

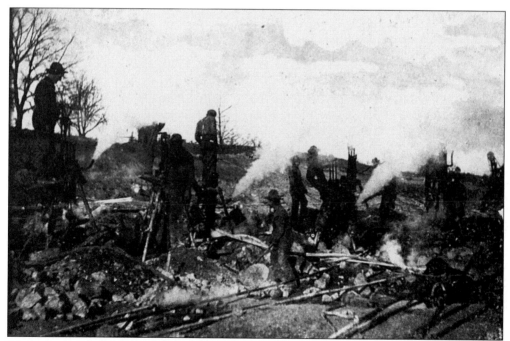

Workmen are shown here drilling holes to set dynamite chargers to blast rock for the DL&W cut-off. All of these drills were run by steam.

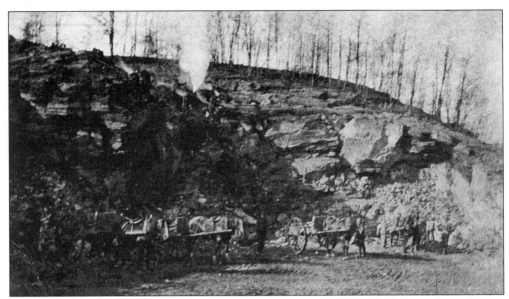

After using the steam drills, the men filled up horse-drawn wagons, which were then taken to the crusher at Hainesburg.

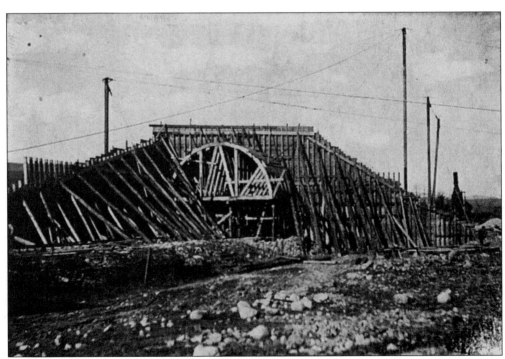

The false work of a cement arch of the DL&W cut-off is shown here.

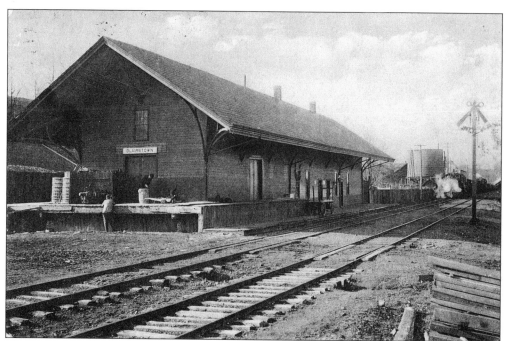

This is the railway depot at Blairstown for the NYS&W trains.

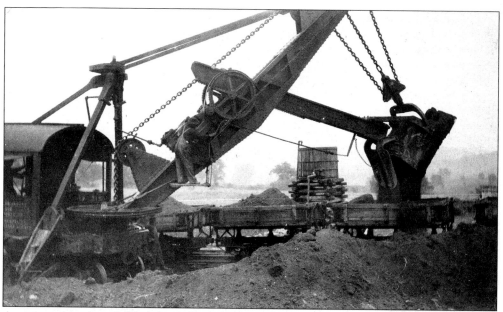

A giant steam shovel filled four-wheeled side-dump cars that were used when building the railroad between Blairstown and Pennsylvania. Notice the large water tank in the back, and how small the man looks standing on the arm of the shovel.

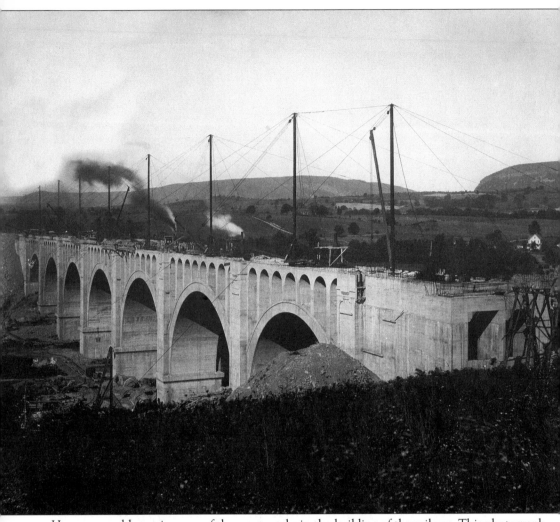

Here we are able to view one of the great works in the building of the railway. This photograph shows the Hainesburg Viaduct being completed over the Paulinskill. Look and see the seventh wonder of the world, the Delaware Water Gap.

Four

A Time for Work

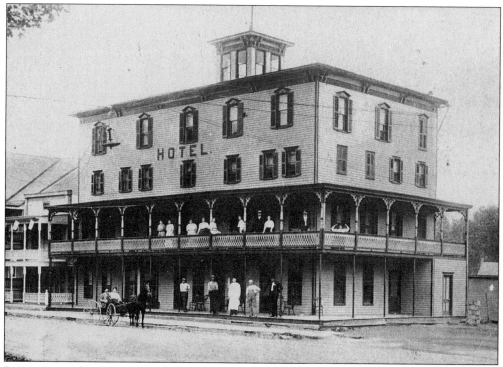

By 1841, travelers were in need of a place to stay overnight, so George VanScoten built a hotel where proper rest and meals could be obtained before starting out on the next day's journey. This *c.* 1880 photograph shows the hotel, which has undergone alterations several times subsequently. It became a favorite stopping place for fishermen and hunters during trout, rabbit, and deer seasons.

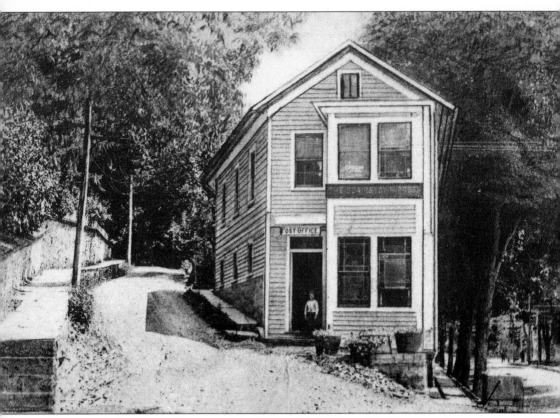

Blairstown's first post office started in 1818, with William Hankinson as its postmaster. Six years later, an ambitious young man named John I. Blair became postmaster. He and his family remained in charge of the post office for the rest of the century. Shopkeepers vied for the postmaster position since the post office was usually within a store and it was naturally more convenient for the patrons to shop in the place they picked up their mail. Blairstown's post office was unusual among rural towns—beginning in 1889, it was located in its own building, called the Flat Iron building, instead of a store. And thanks to John I. Blair, there was no political turmoil over who had to be postmaster, because he decided who was postmaster and that was that. Blair appointed his son-in-law, John Vail, as postmaster from 1875 to 1901. It is said Vail was postmaster only in name, appearing in the post office only long enough to establish his position, leaving much of the work to his clerk, H. Hartman.

The first daily mail to Blairstown was in 1860. At one time as many as nine mail deliveries came to Blairstown each day, with the greatest excitement occurring at 6 p.m., when the last mail run came in.

In the year 1898, rural mail delivery was given a trial run in New Jersey. Only seven post offices were chosen, and Warrington (located then by the "Kill" in Knowlton Township) was one of them. As insignificant as Warrington was, it became one of the first rural delivery post offices in New Jersey, delivering mail to 470 patrons in an area of 12 square miles.

Blairstown was not included because residents liked coming to town to visit and see one another for news. On April 1, 1936, the post office moved across the street to the brick corner building. Moving was done at night so as not to disrupt the mail service. When customers came to the Flat Iron building the next day and found the doors closed, they thought it was an April Fools joke. The Blairstown Post Office was also distinctive because it was the only post office in the state to have a walk-in vault. In 1966, the post office moved again to its present site on Main Street.

46

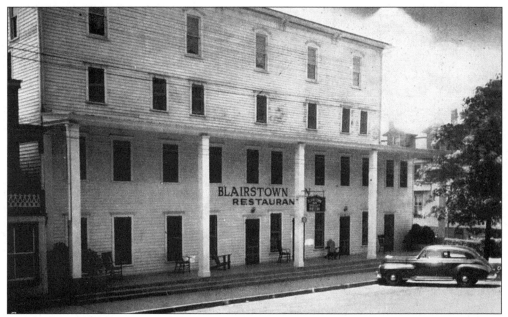

The Blairstown Inn is shown here during its later years on Main Street. Viola Williams was the owner at the time this photograph was taken. It was said Babe Ruth spent many nights here.

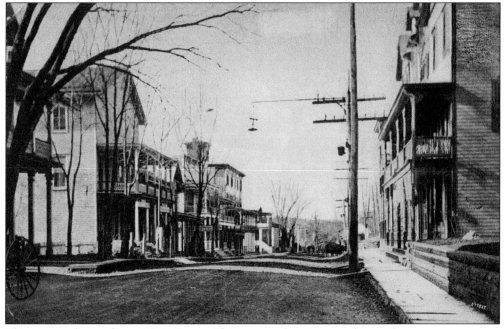

This picture depicts lower Main Street, Blairstown, when it was a dirt road.

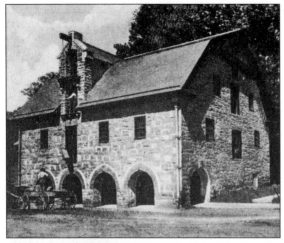

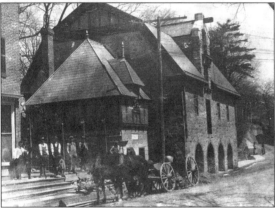

Upper Left: This is what The Mill on Main Street looked like after a 1903 renovation. The gristmill was run by Messler and Shannon until 1932, when it last ground feed for the local farmers. By the mid-1950s, the Catherine Dickson Hofman Library had taken over.

Left: The Mill is shown here with a horse and wagon loaded with feed.

Below: A southern view of Main Street shows how many businesses were on Blairstown's Main Street. Many nights the town did not close down until 10 p.m. and as late as 11 p.m. on Saturdays.

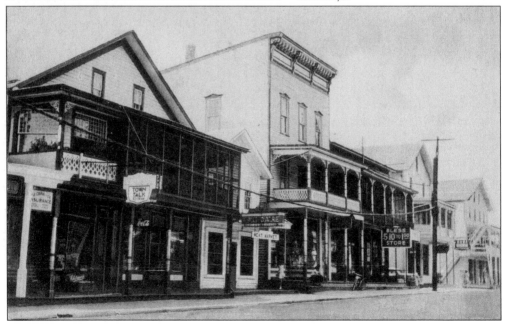

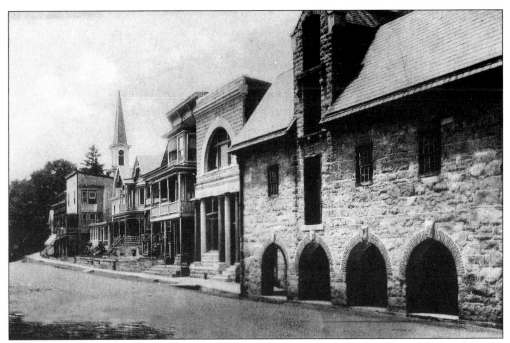

A view of the opposite side of Main Street looking south shows the First National Bank's second building, which opened its doors around 1910. The bank was founded on December 10, 1900, and originally conducted business in a building farther south on Main Street.

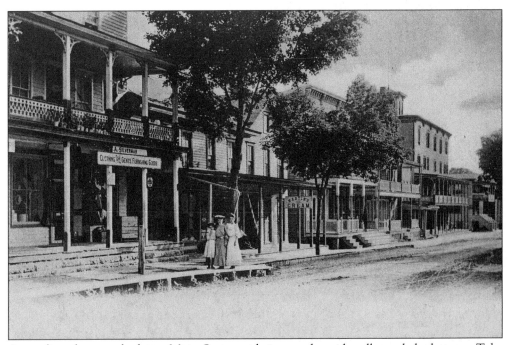

An earlier photograph shows Main Street with its wooden sidewalks and shade trees. Take notice of "Silverman's Dry Goods Store" and "Martin's Ice Cream" for those dog days of summer.

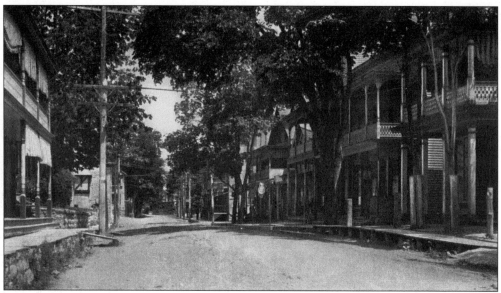

A northern view of Main Street shows more shade trees lining the street. It gives you a glimpse of an easier way of life.

The First National Bank of Blairstown was built to make it look impressive, safe, and sound. Here you see all the marble and granite put in place by a horse-powered pulley system.

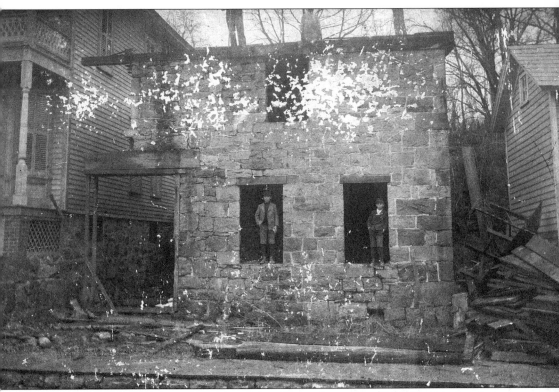

This *c.* 1895 photograph of the north side of Main Street shows the old blacksmith shop being torn down to make room to erect the building that housed the First National Bank of Blairstown. To the right is David Sliker's shoe store, better known as "Sliker's Curiosity Shop." It was Blairstown's first museum and reported to have had the most extensive collection of arrowheads, stone axes, grinding stones, and chipping stones in New Jersey. Most of these artifacts were found on a trail from Blairstown to Brand's Bridge.

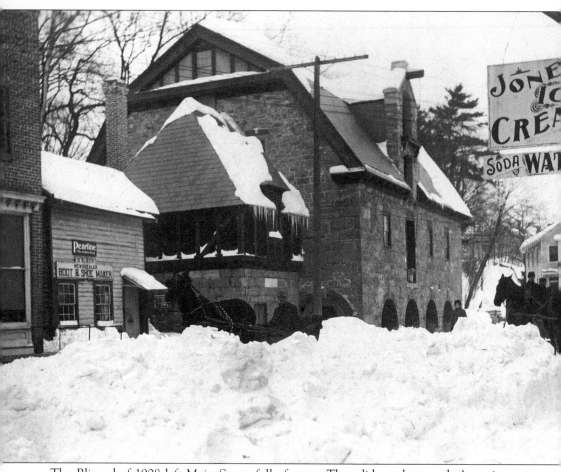

The Blizzard of 1908 left Main Street full of snow. They did not have today's equipment to remove the snow, so they used horse-drawn sleighs to get around. Blairstown had many confectioners and here we see Clarke Jones's store, popular not only for his ice cream, but also for his roasted peanuts.

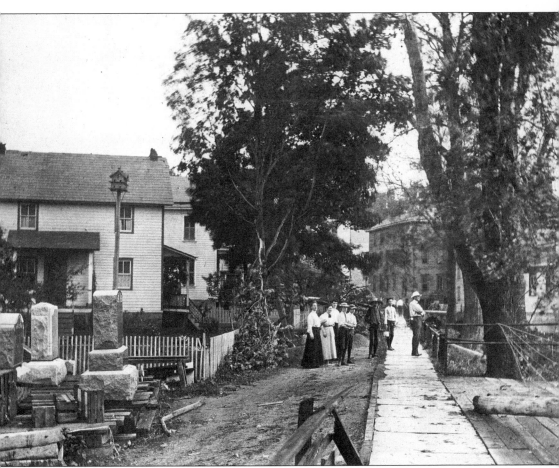

Here we are looking at what is known today as Carhart Street. All it had was a wooden sidewalk and a horse and buggy path. To the left of it is Marble Yard, which began in business producing monuments and grave markers around 1895. It was first owned by Jacob Beuz and later by Lew L. Drake.

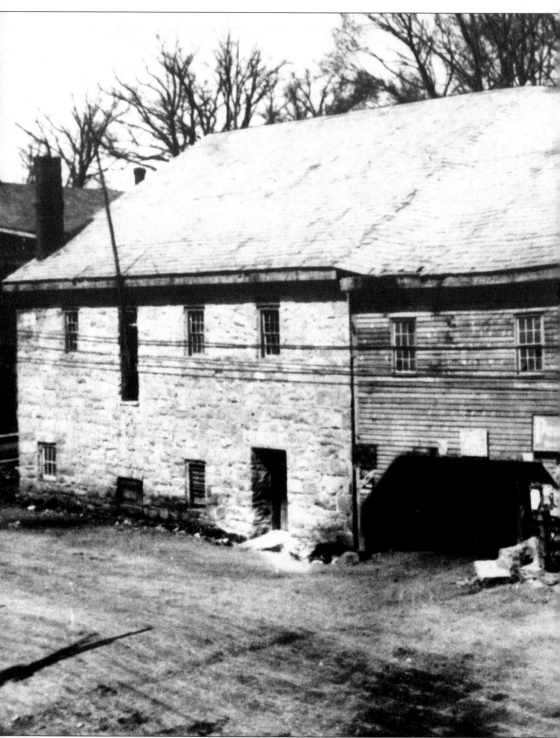

The Old Mill, built around 1825, was a two-story structure whose original lines can still be seen in the present building. About 30 years later, a wooden addition, extending to the creek, was constructed. As time went on, it became so shabby and unsightly that in 1899 the town urged

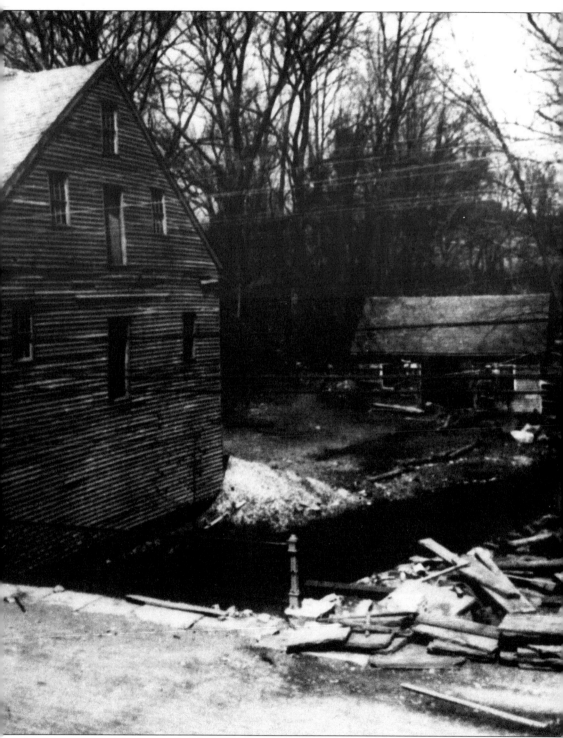

the destruction of the gristmill. In 1904, Blair Academy purchased the mill and changed the future appearance of the town. The wooden addition was torn down, a third story and stone arches were added, and the mill soon became the pride of Blairstown.

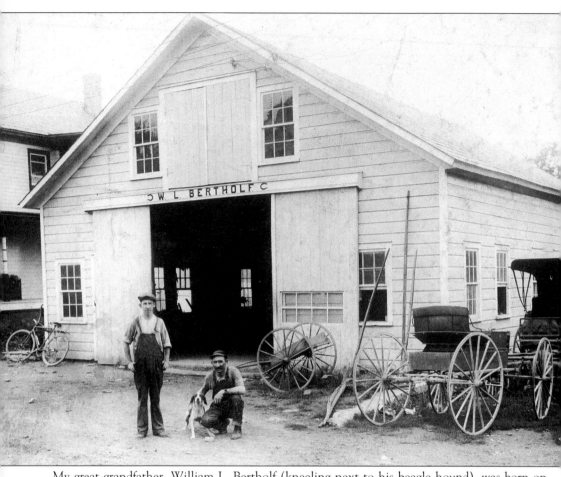

My great-grandfather, William L. Bertholf (kneeling next to his beagle hound), was born on August 9, 1878, and was the owner of this blacksmith repair shop just off Main Street. Standing next to him is his son, Raymond H. Bertholf, born November 30, 1898. Raymond was the oldest of William and Olive Reeder Bertholf's six children.

Five

A TIME FOR PLAY

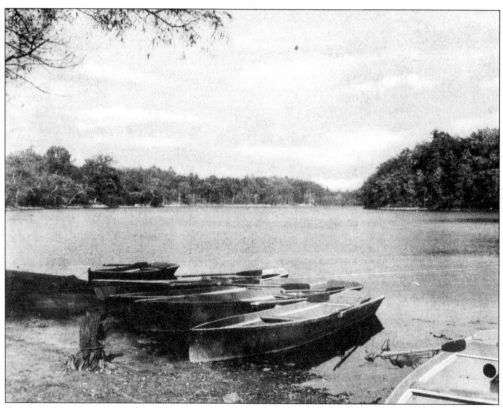

Camp Sakawawin at Cedar Lake started sometime in the late 1920s. It was a very active and well-attended camp for years.

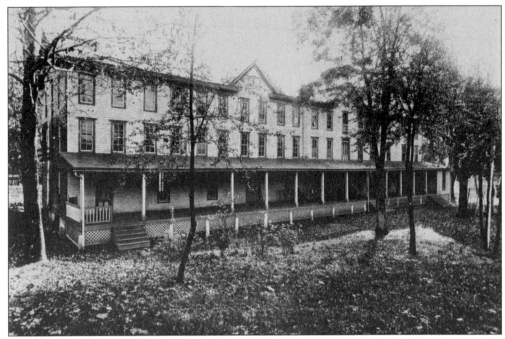

The very first boarding house in all of northern Warren County was the Cedar Lake House, which opened in 1869. The first camp was at Cedar Lake. In 1892, a Princeton professor and some friends put up a few tents at the west end of the lake and roughed it for a few weeks.

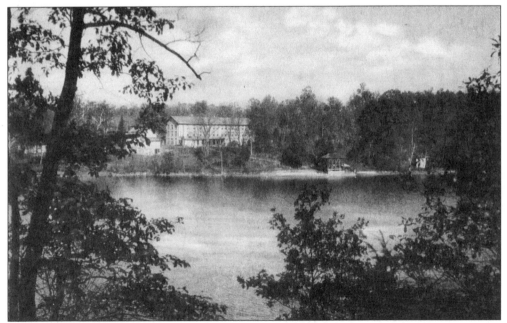

Looking across Cedar Lake, one can see the huge Cedar Lake Lodge at Blairstown.

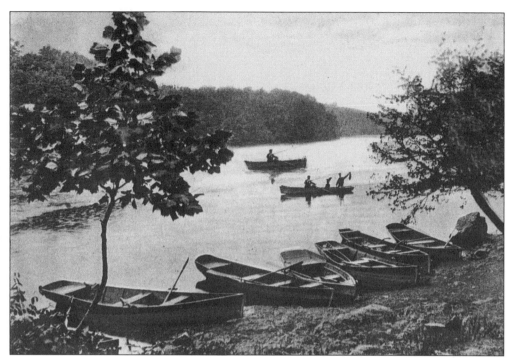

One of the many attractions at Cedar Lake Lodge was the boating and great fishing.

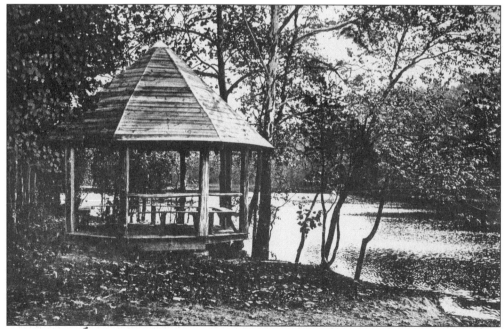

At the edge of Cedar Lake there is a great gazebo where many people have spent their evenings relaxing by the water's edge.

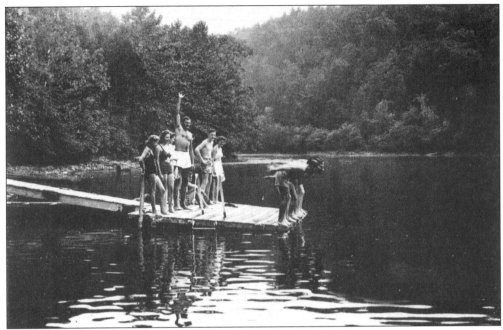

The camp counselors of Camp Sakawawin at Cedar Lake were great swimmers. It is told they had a 20-foot-high diving board. Sometimes it would take up to ten minutes for counselors to get up the nerve to jump.

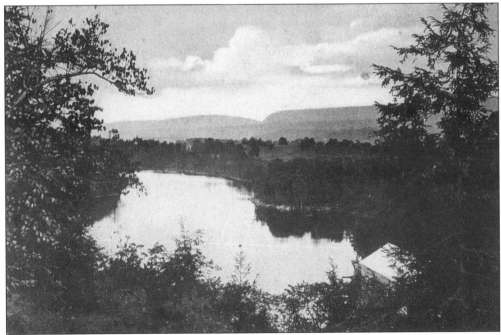

Cedar Lake is shown here from the hilltops. The Kittatinny Mountains are in the background; note the Delaware Water Gap.

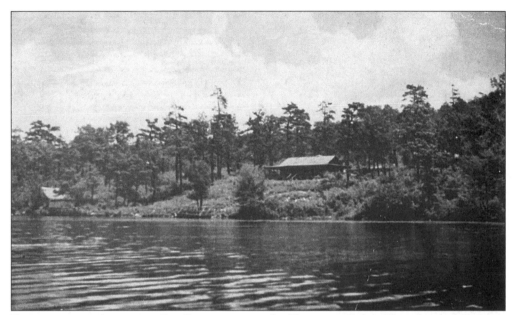

For many years, there was a Boy Scout camp on the Kittatinny Ridge. This photograph shows the administration building near the lake.

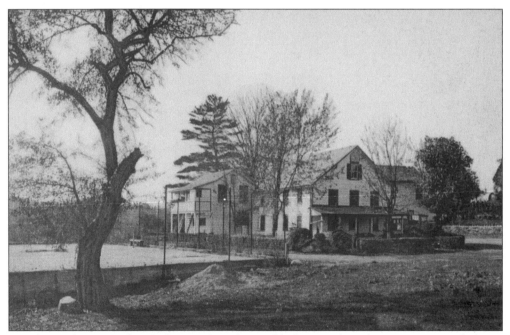

Another early inn, Ferla's Cedarmere Inn, featured lodging and outdoor activities, including a tennis court. They served local residents as well as tourists.

Camp Kalmia on Lake Genevieve, just north of Blair Campus, was bought in 1927 by the Newark Girl Scout Council. It was a large and active camp in a beautiful location, 125 acres of forest and fields, with a plantation of tall pines around the attractive lake. This photograph shows the recreation hall; it was closed in 1970 because of growing camp expenses.

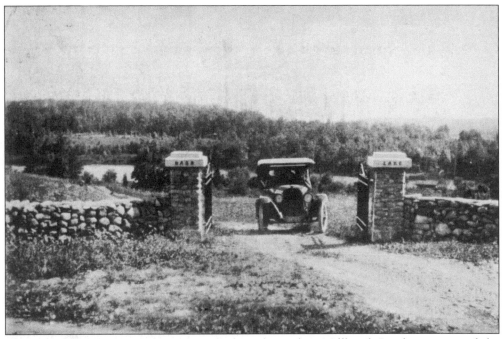

The entrance to the Bass Lake Summer Colony, located on Millbrook Road going toward the mountain, is shown here.

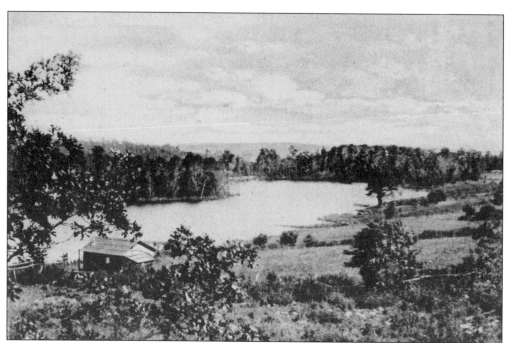

These summer cottages appear in a photograph taken looking north across Bass Lake.

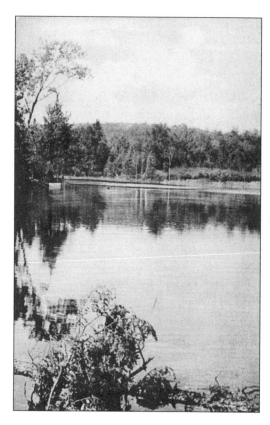

For the eye of the beholder, this is Bass Lake and its natural beauty.

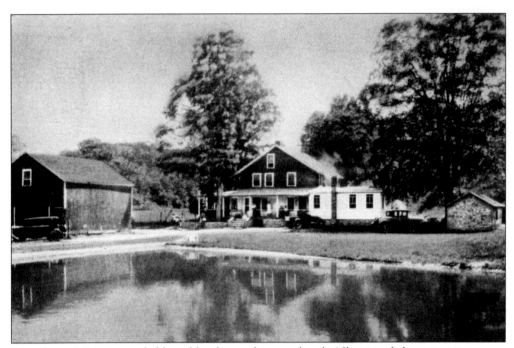

The Cecconi Farm provided board by the week or weekend. All enjoyed the quiet time spent fishing, hunting, and swimming. This was one of the few camps open year-round.

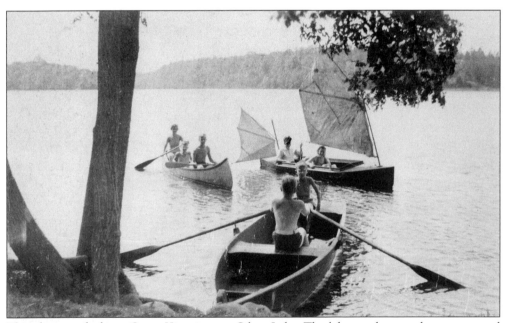

This photograph shows Camp Kittatinny at Silver Lake. The lake was large and was very good for boating and swimming. Notice the attractive sailboat.

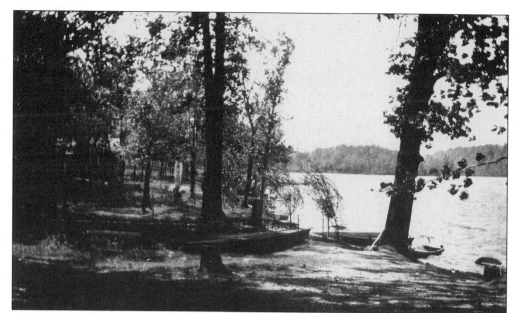

Silver Lake, named for the clear, silvery appearance of its waters, covers about 100 acres.

Here we have the old bench and hand pump for water at the end of the Foot Bridge in Blairstown. On many hot afternoons this old water pump was used, while stories were told under the shade tree.

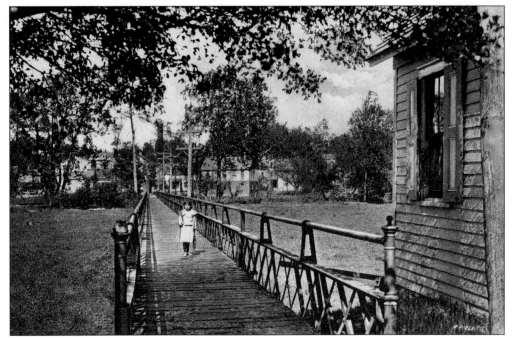

The Foot Bridge across the Paulinskill and the meadow from Blairstown to the railroad station served the important function as a main entrance and exit artery for the townfolk throughout the years. The original Foot Bridge was built in 1877 by John I. Blair. It was made of planks with a railing on one side, except where it crossed the Paulinskill. The bridge survived the devastating floods that occurred in 1903 and 1955, when it was almost completely covered by flood waters and debris.

In earlier days, the Paulinskill had a beautiful Native-American name given by Tammany, Chief of the Delawares. It was called "Tohockonetcong," meaning "beautiful valley below the blue mountains."

Few villages have the rustic beauty as found in Blairstown's surrounding countryside. The steps and entrance to Blair Lake, in the center of the village, provide another approach to the beautiful grounds which surround Blair Academy.

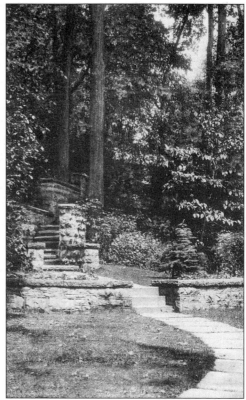

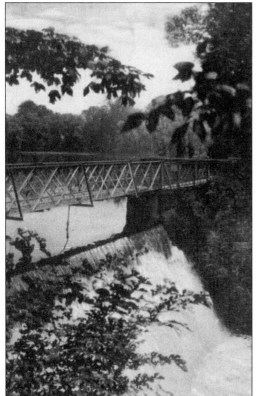

The dam to create Blair Lake was built around 1903. By doing this they covered over what was known as Blair Meadow. The dam was built out of cut limestone and has never been repaired.

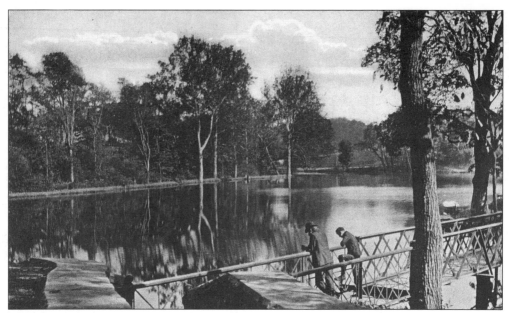

Here we see Blair Lake from the stairs leading up to the lake. The walkway has been there for many years and if you want to feel a cool breeze, just stand on the walkway and feel the mist from the water going over the dam.

This is a picture of the walking path that surrounds Blair Lake. It is said many young men have asked their sweethearts to marry them while walking on this path.

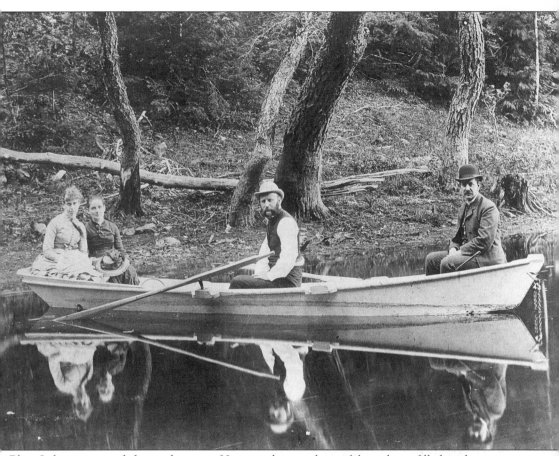

Blair Lake was noted for its boating. Here we have a beautiful rowboat filled with some townspeople enjoying a Sunday afternoon.

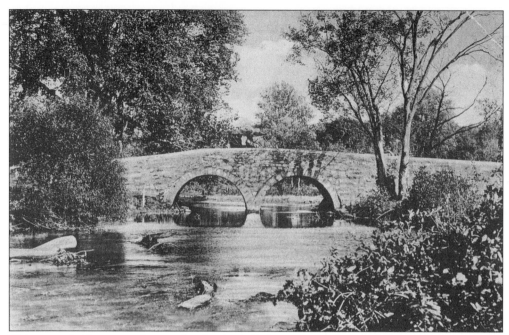

This stone bridge crossed over the Paulinskill. It was torn down when Lambert Road was constructed.

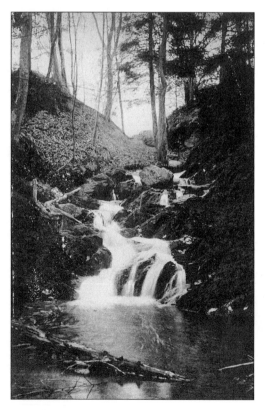

Slate Quarry Falls is located on Jacksonburg Creek between Cobblewood Road and Jacksonburg. The falls are located up in the great pine and hemlock forests. The water is cold and clear and has a very deep pool for swimming.

The Rocks are located on Bear Cave Road. There are many caves within The Rocks and legend has it that many a bear lived in these caves, thus the name Bear Cave Road.

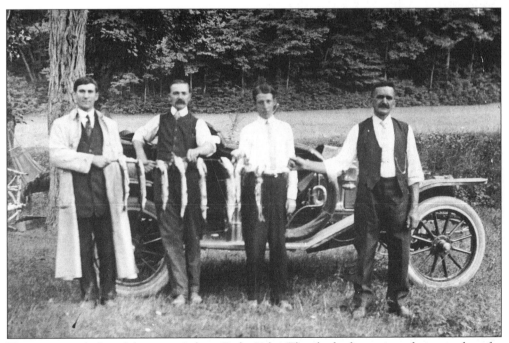

These men took their fishing seriously at Cedar Lake. They had a fine string of trout to show for their day's work.

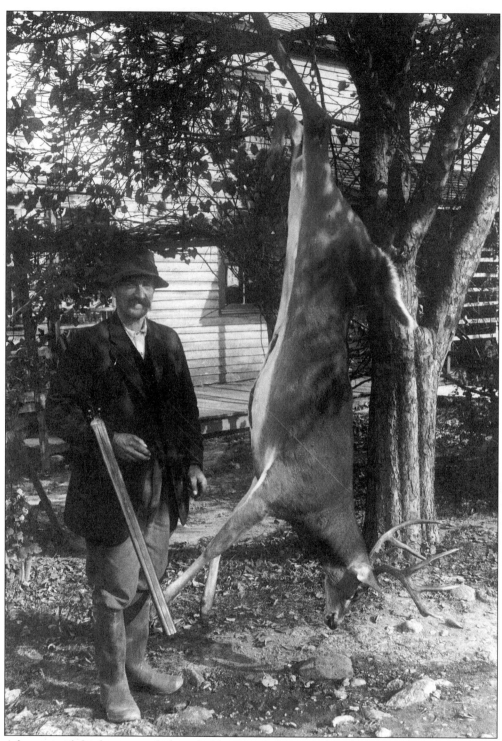

A hunter with his hammer side-by-side 12-gauge shotgun. Notice the size of that buck. It was a great treat to take a deer in those days, as they were small in population. People would come from miles to see the hunter's bounty.

Six

VOLUNTEERS AND
VALIANT EFFORTS

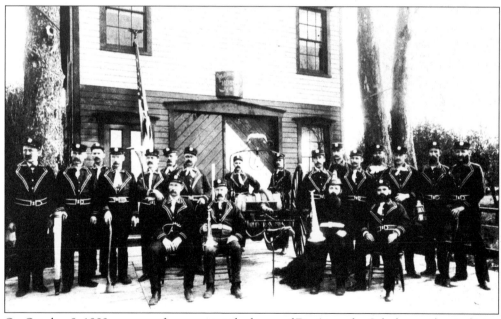

On October 8, 1889, a group of men met at the home of Dr. Amandus Schubert, a dentist living on Douglas Street, to organize the Blairstown Hose Company. The company was formed to protect the community from fire and reduce insurance rates in the built-up area of the town. Walter Wilson and John I. Blair donated land and a building on Carhart Street to house the fire company. Emma King donated the company's first bell, which she paid for from her earnings as a music teacher.

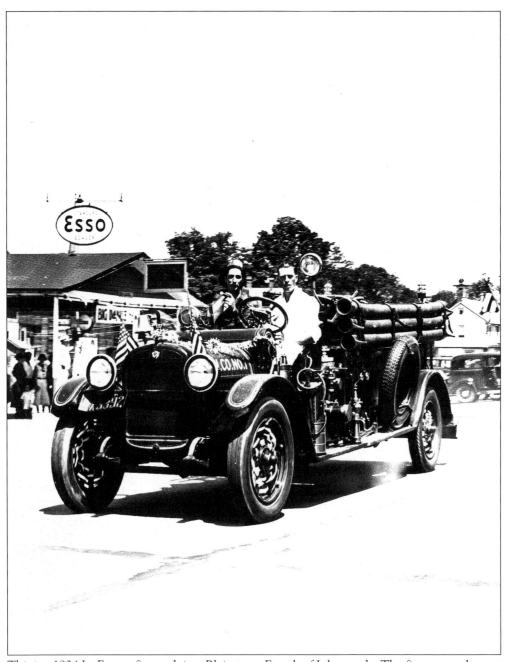

This is a 1924 La France firetruck in a Blairstown Fourth of July parade. The firemen took great pride in their equipment.

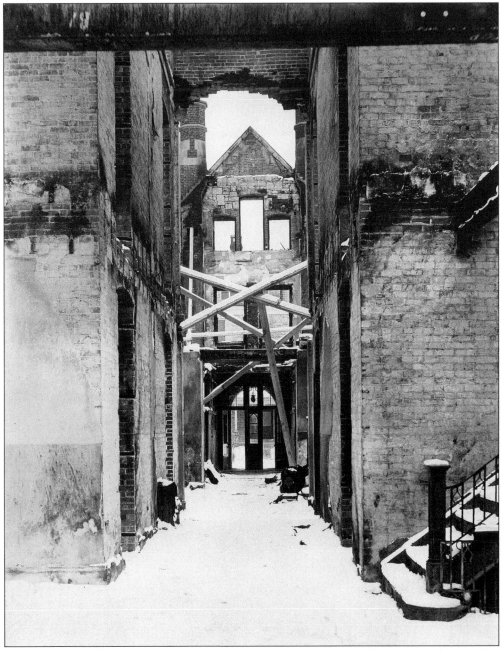

Pictured here is Clinton Hall at Blair Academy after the fire destroyed it on December 8, 1922.

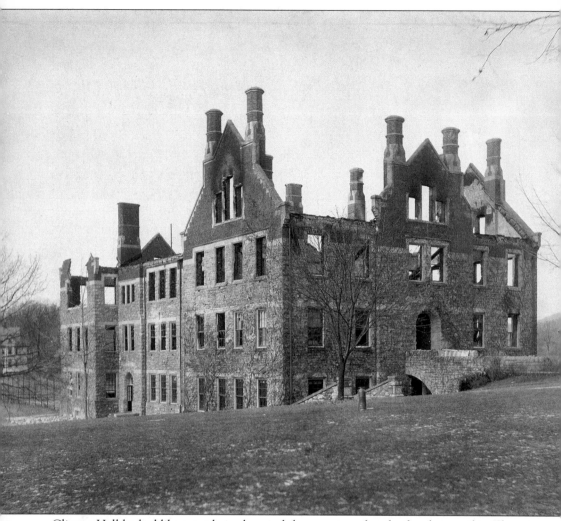

Clinton Hall looked like a castle in the wind the morning after the fire destroyed it. There was no one hurt in this disaster.

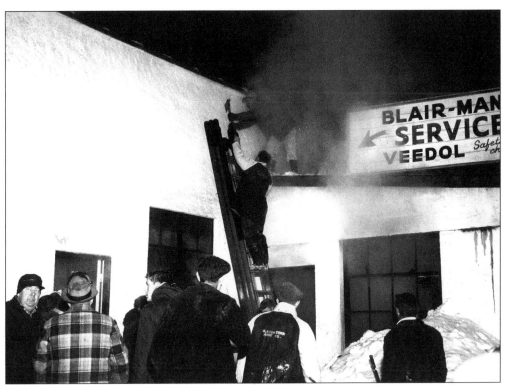

The Blairstown Fire Company responds to a call at the Blair-Manning Garage.

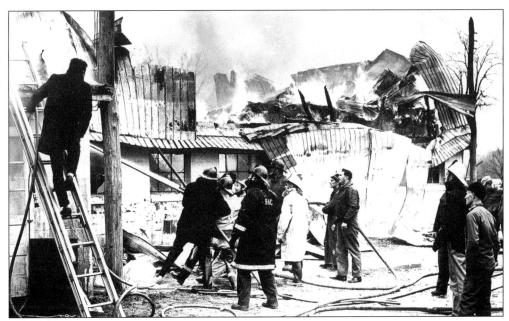

Here we see Blairstown firefighters at a local barn fire. Such fires were devastating—not only was a building lost, but many livestock as well.

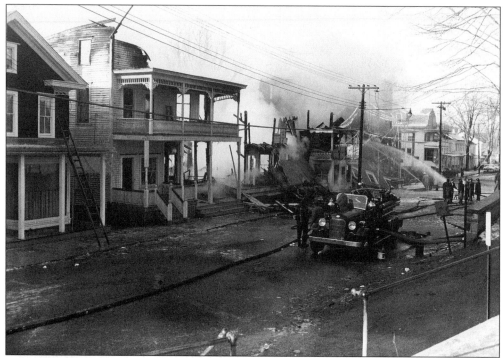

Considered the worst fire in the town's history, the "Main Street Blaze" of March 1, 1957, was the biggest fire our firefighters have ever had to face. It raged for more than eight hours and consumed four buildings—The Blairstown Inn, Marie's Luncheonette, and buildings owned by Amzi Linaberry and Louise Weber. A total of 10 fire companies were called to the scene.

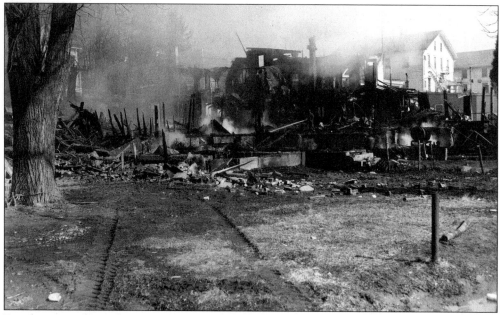

Fire damage is shown here in a photograph taken from Vail Street. When the blaze was finally extinguished, some 35 people lost their homes and most of their belongings.

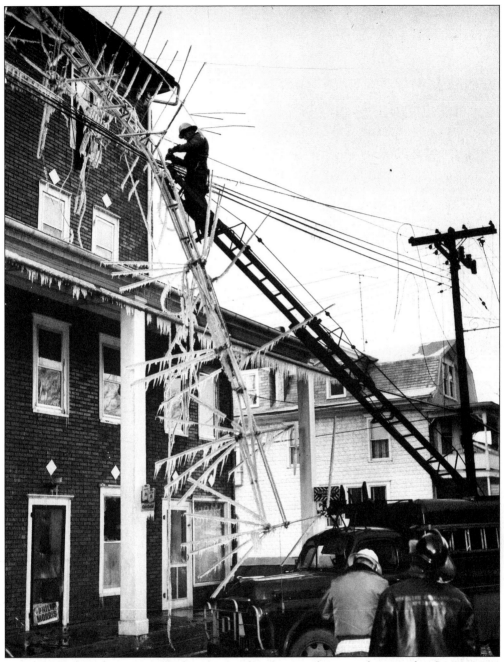

Power and light repairmen worked to restore electricity to the town the next day. It was a very cold night and the mist from the water being used to extinguish the fire turned to ice.

Douglas Race, chief of the Blairstown Hose Company's centennial year (1889–1989), removed the original bell on the old firehouse on Carhart Street. It was used to celebrate the 100th anniversary.

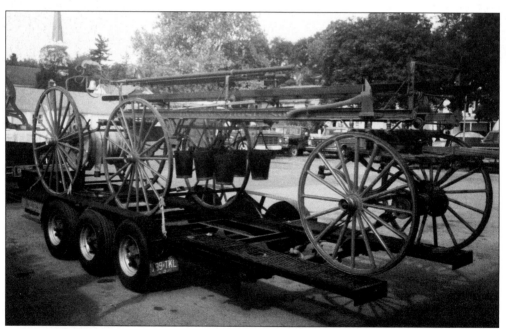

This is the original ladder-and-bucket wagon used by Blairstown firemen in 1889, as seen during the 100th anniversary parade.

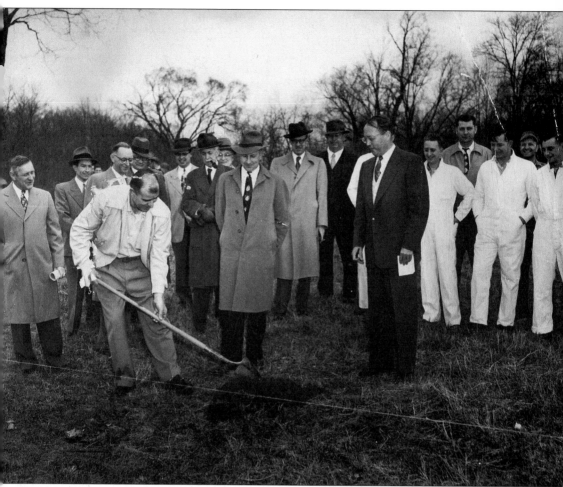

The Blairstown Ambulance Corps was originated in June 1952, after a resident fell and waited two hours for an ambulance and first-aid help to arrive. The corps purchased land for its present location from Mr. Alfred White, with the stipulation it be used exclusively by the Ambulance Corps. A groundbreaking ceremony by charter members and town officials for the first building took place in March of 1953.

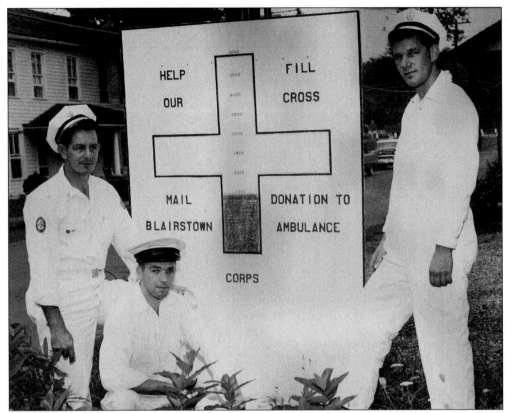

From left to right, Blairstown Ambulance members Harold Sandberg, Sal Simonetti, and Ted Roth pose as they register the amount of donations received during an annual fund-raising drive. A black mark is drawn at $1,500 with $5,000 as the ultimate goal.

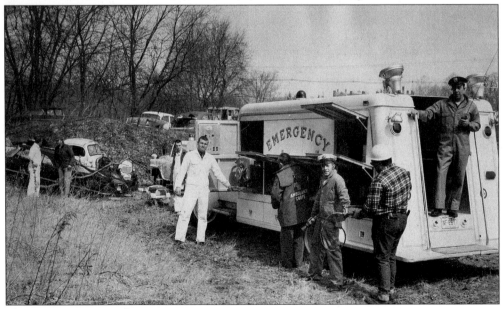

These men participated in a training session.

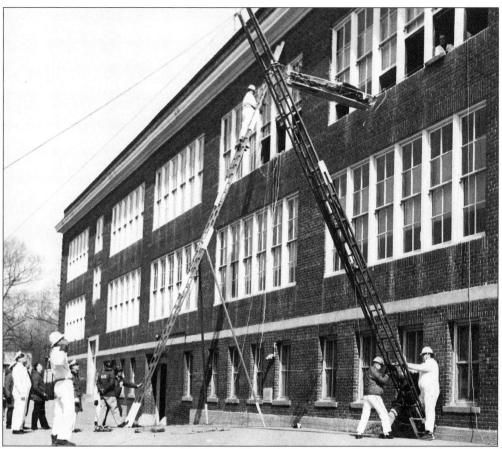

The town of Blairstown worked with Hackettstown on a building rescue drill.

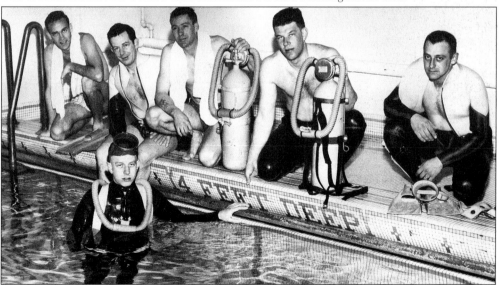

In 1960, the Ambulance Corps diving team devised the first circular pattern to search for drowning victims. The diving team practiced at Blair Academy's pool.

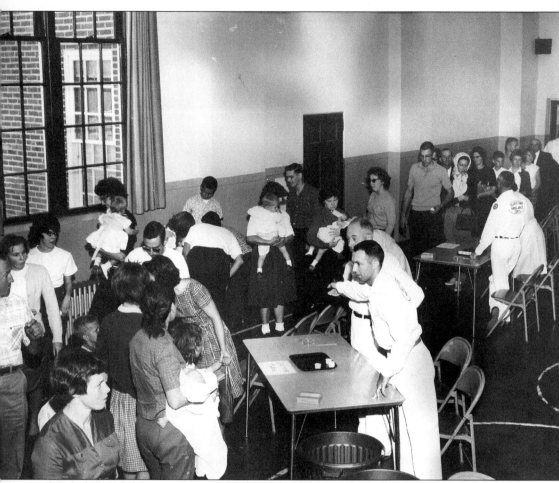

Blairstown Ambulance Corps members administered the polio vaccine given out at the old Blairstown High School.

Seven

EARLY EVENTS

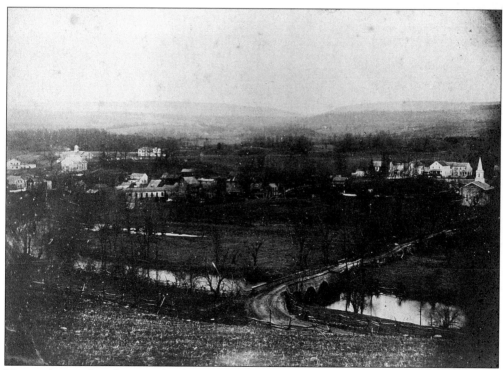

How early was this photograph taken? On the right is the old First Presbyterian Church, so it was after 1838. There is no railroad, so it was before 1877. The Stone Arch Bridge with the Paulinskill flowing under it was built in 1840 by John Quick of Mansfield Township. Buildings on the hill to the left were part of Blair Hall. Blairstown has gone through many changes over the years; some of these changes were directly linked to major events.

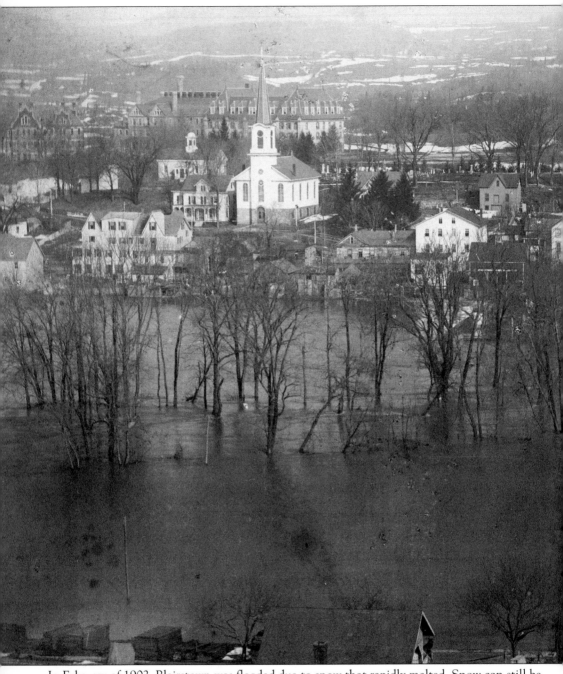

In February of 1902, Blairstown was flooded due to snow that rapidly melted. Snow can still be

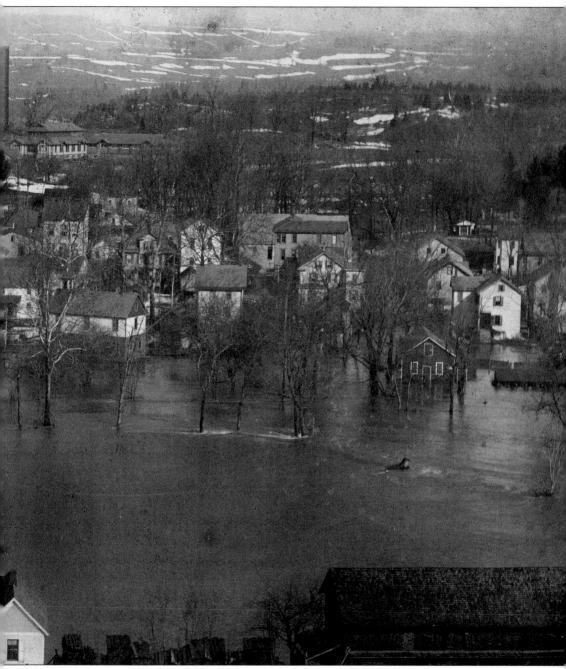

seen in this photograph taken from Edgehill looking down at the old railway station.

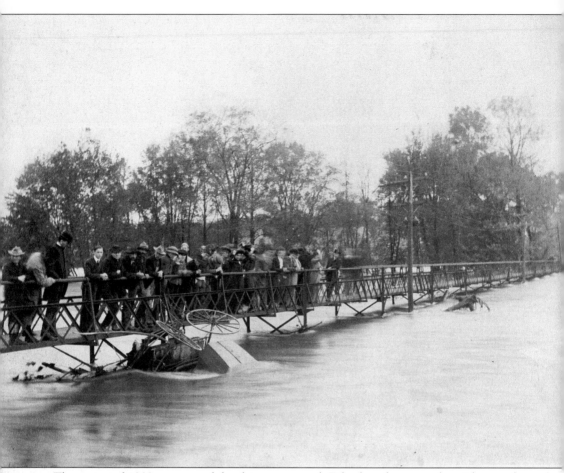

The spring of 1903 was one of the driest on record. Fifty-four days went by without a drop of rain. June made up for it with 24 days of rain, and by October all the streams were high. Heavy rain in October culminated with a 9-inch downpour. Within 24 hours the Paulinskill covered all the streets in town. This view of the Foot Bridge to the rail station was taken before Route 94. Despite the fact that it almost became a dam when all kinds of material, including trees and wagons, wedged against it, the bridge still held up and is used to this day.

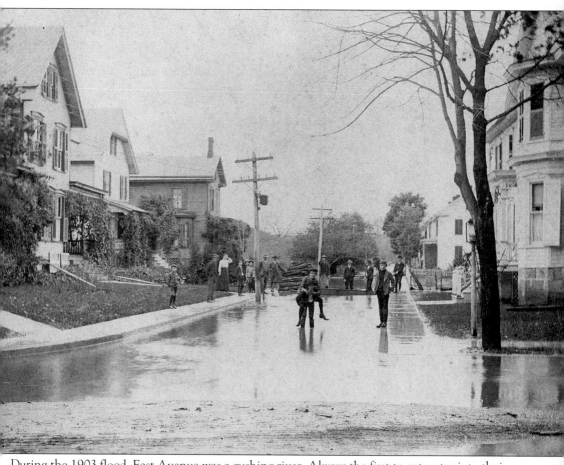

During the 1903 flood, East Avenue was a gushing river. Always the first to get water into their cellars, the residents of East Avenue had plenty of company that year, as many other homes experienced the same.

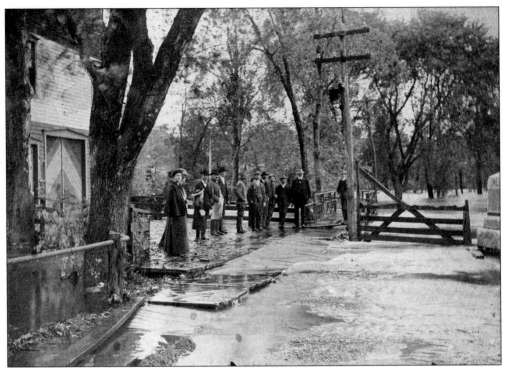

This photograph was taken in front of Blairstown's first firehouse during the 1903 flood. The fashionably dressed folks looking at the water could not have stood in the same spot a week earlier without being soaked.

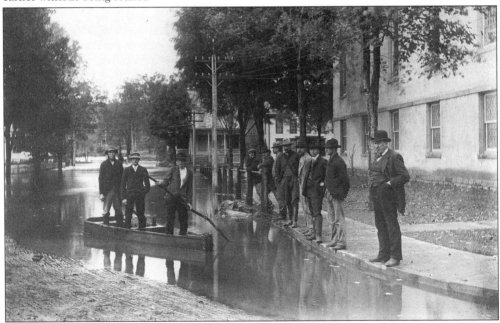

For years, townspeople described how people rowed around the First Presbyterian Church in boats during the 1903 flood. It has been said these young men made a lot of money transporting people by boat.

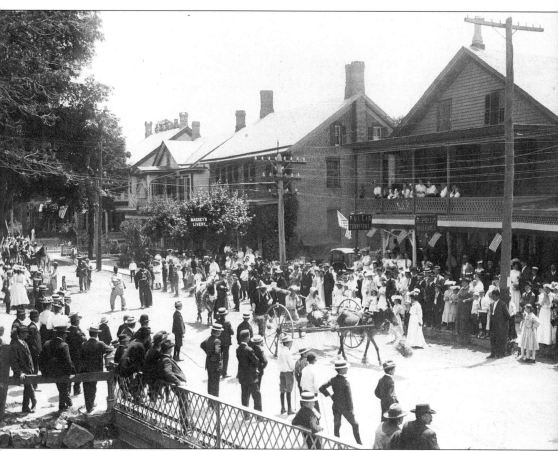

During horse-drawn buggy days, when people couldn't get very far, Independence Day was a big celebration. The day started out with church bells ringing, cannons booming, and firecrackers popping. Main Street, Blairstown, was always thick with red firecracker papers at the end of this celebration. Here is a photograph of the 1907 July Fourth parade crossing the bridge over Blair Creek on Main Street.

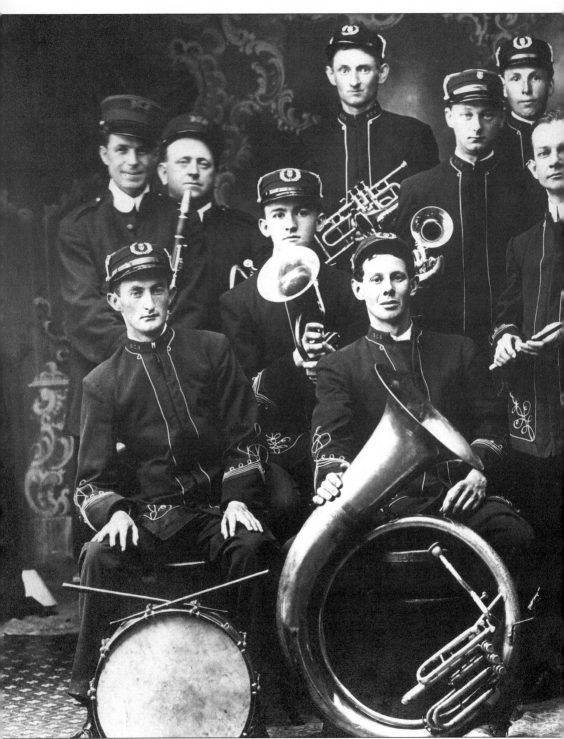

The Blairstown Concert Band was formed on February 7, 1911, and included coronets, snare drums, a bass drum, slide trombones, and cymbals. They wore snazzy blue uniforms with red trim and were quite popular during their day. Every weekend the band gave a concert on Main Street

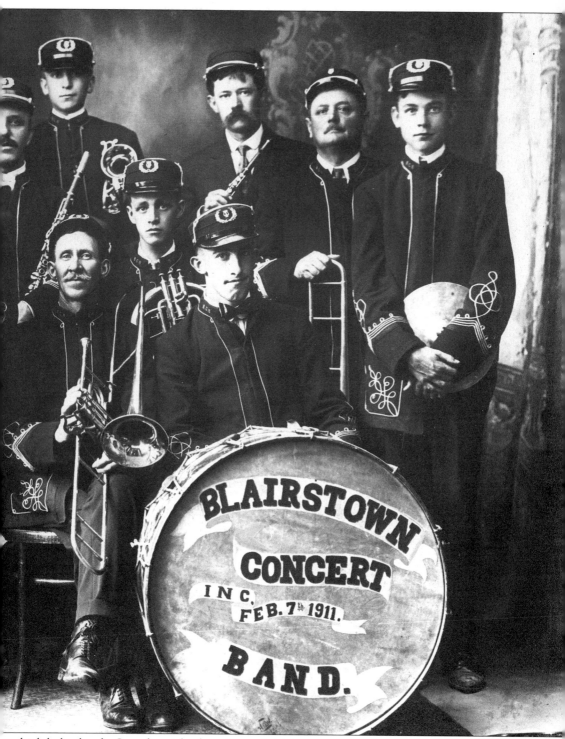

which helped make Saturday night shopping and visiting even more pleasurable. Bands in those days were composed exclusively of men and older boys. The idea of girls or women playing in a band was unthinkable. Sometime in 1917 the band broke up.

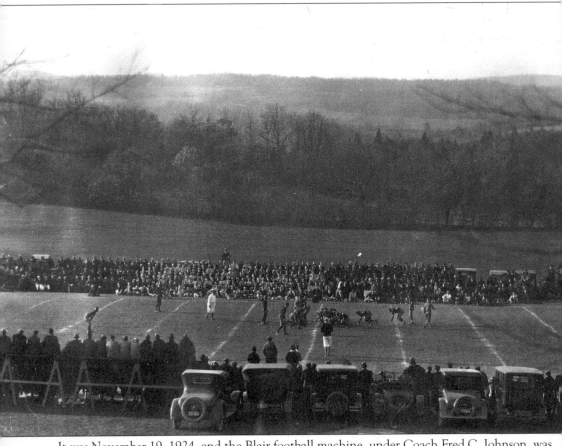

It was November 19, 1924, and the Blair football machine, under Coach Fred C. Johnson, was about to play the undefeated Peddie team. Peddie arrived at Blair escorted by the student body, full of confidence. Newspapers predicted an easy victory for the boys from Peddie. But in one of the most thrilling games ever witnessed on a local gridiron, the Blair team triumphed over the powerful "Peddie Eleven" by a score of 7-3. This game was marked by fine sportsmanship and many spectacular plays.

Eight

NEIGHBORS

This view of Hope, taken before the fire of 1918 and before the town streets were paved, shows the road leading to the mill. Also on this street is the Theodore Seals Store, famous during the late 1890s for its acetylene gas-generated lighting. Note the hitching posts in front of the buildings.

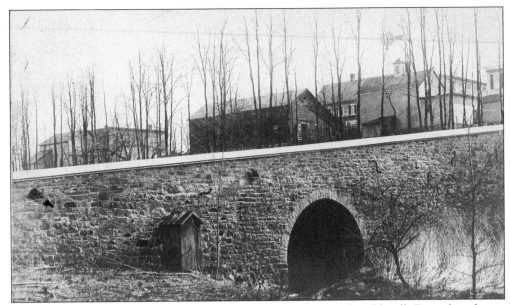

The Old Stone Moravian Bridge, built in 1768, led the way to the old mill. Even though it is known as the Moravian Bridge, it was not built by them.

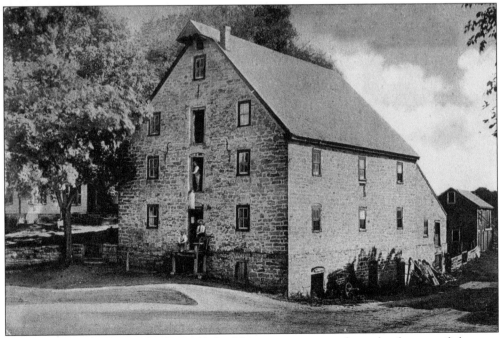

The gristmill, which was the basis of the Moravian economy, kept the farmers of the area supplied with flour. During the Revolutionary War, it was one of the New Jersey mills that supplied Washington's Army at Morristown.

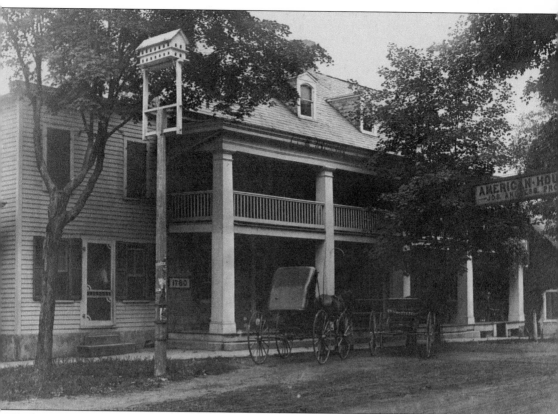

The lower story of the south end of the American Hotel was originally one of the Moravian houses. It was occupied as a doctor's office by Gideon L. Leeds, M.D., and owned by Daniel Mitsell, who sold it to Abraham Freese in 1844 and converted it into a hotel.

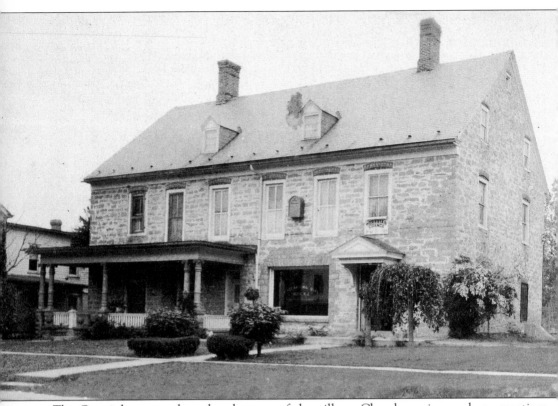

The Gemeinhaus was the cultural center of the village. Church services and any meetings called by the Mother church were held here. In 1824, the building was converted into a hotel. In this building the first courts for Warren County were held. Hope became a rival of Belvidere when the question of a county seat was determined. In 1912, a group of local men purchased the building and started the First National Bank of Hope.

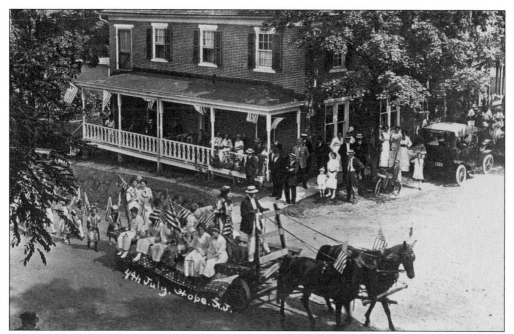

The Daughters of Liberty float moves by during the 1909 Fourth of July parade at Hope. The Daughters of Liberty hosted a celebration.

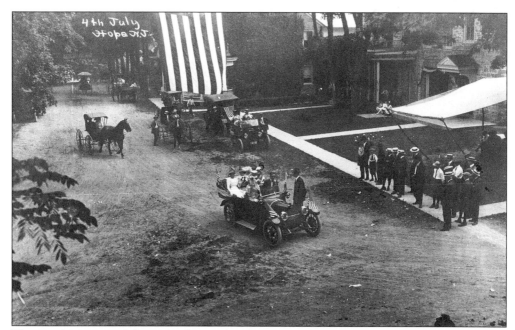

The parade continued down the dirt road at the center of Hope.

The village blacksmiths, Hope, took a moment to have their photograph taken. Elaborate billboards announced upcoming events.

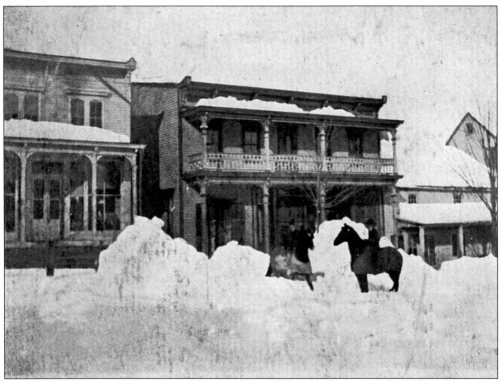

Horsemen ride through the streets of Hope after a blizzard.

100

This is a view from the gristmill facing the center of Hope.

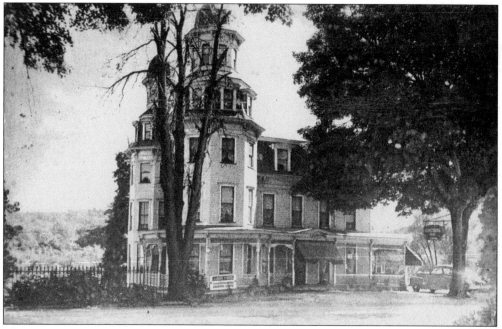

The Mansion House or Andress Home has been a pictorial landmark of Hainesburg for many years. Approaching this once productive settlement, the Andress Home was indeed a breathtaking vision. Its castle-like structure, amid a combined countryside and once flourishing town, was a welcome sight to frequent visitors. Joseph Andress and his family once lived in and owned the Mansion House. It was believed Andrew Smith built it in the early 1800s. In addition to his house, Andress also owned and operated two stores.

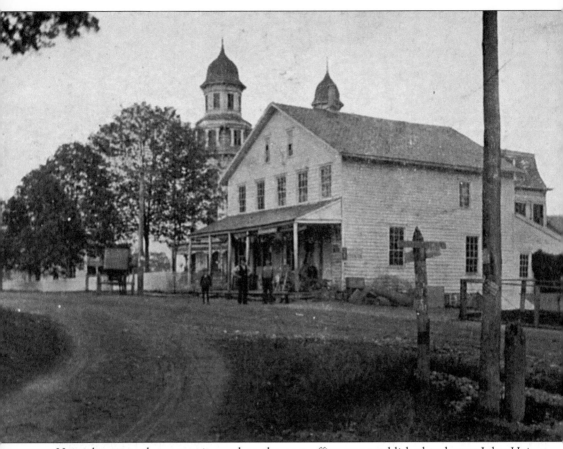

Hainesburg was the name given when the post office was established to honor John Haines, who made a liberal donation to the school district in which the village is located.

This ancient looking village is located on the Paulinskill about 4 miles north of the Delaware River. For many years this locality bore the name of "Sodom" to warn the dwellers therein of the fate that befell its ancient namesake, or for other reasons we do not know.

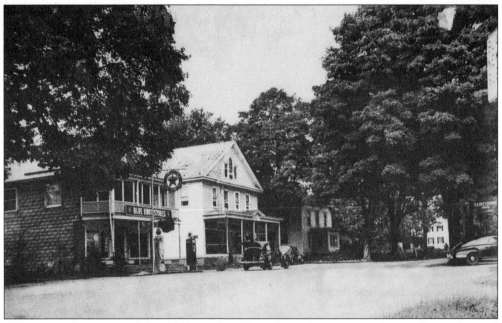

This is a northern view of the old Route 8 in Hainesburg. At one time, this small town boasted of a blacksmith shop, a wheelwright shop, a post office, two stores, a hotel, a church, a tannery, a grain mill, and even a brewery.

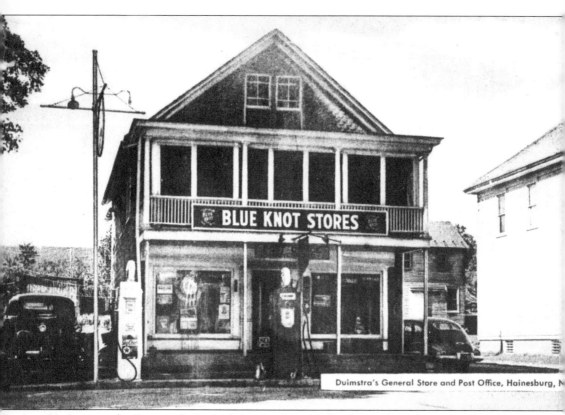

Duimstra's General Store and Post Office, Hainesburg, N

Here we see the Duimstra's General Store and Post Office located on Route 8 on the south end of Hainesburg.

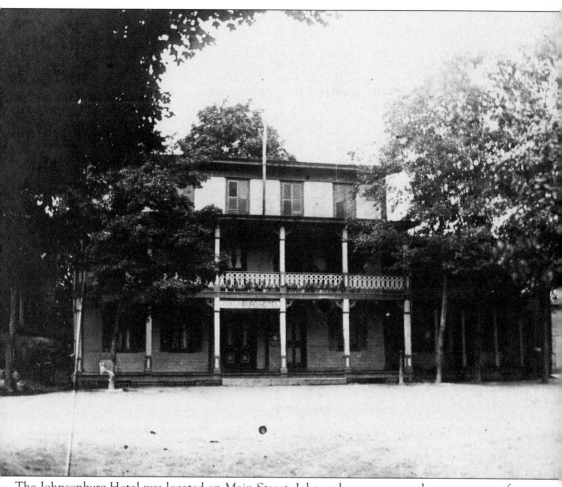

The Johnsonburg Hotel was located on Main Street. Johnsonburg was once the county seat of Sussex County and for many years it was known as the "Log Gaol."

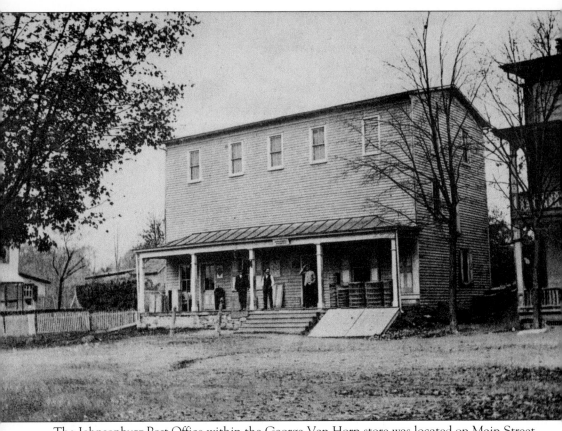

The Johnsonburg Post Office within the George Van Horn store was located on Main Street.

In Johnsonburg, during the year 1826, a new stone schoolhouse was built on land bought from John Middlesworth. The construction of this building cost about $500. Elam March was the first teacher in the new building. He is remembered as a worthy and estimable man.

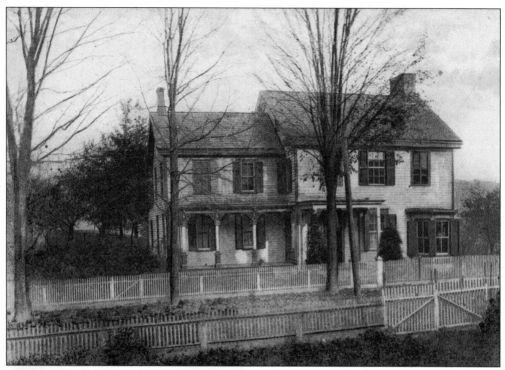

This is the home of George Van Horn.

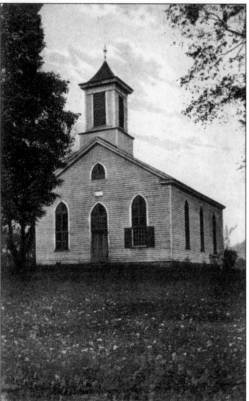

Men of God, in good and honest hearts, organized the Methodist Church in Johnsonburg. In 1850, during the administration of Rev. Van Cleve, the society built their church at a cost of approximately $1,500. Isaac Dennis donated the lot upon which the church stands, and also gave $500 toward the building itself. The church was built by Mr. Flomerfelt and Bishop James dedicated it.

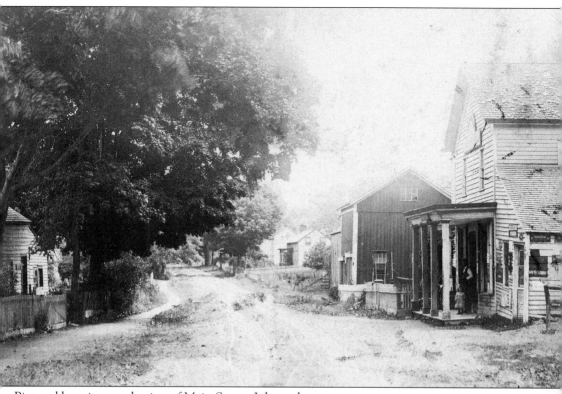

Pictured here is an early view of Main Street, Johnsonburg.

The Adams/Fairview Schoolhouse was built in 1835, a time when octagon buildings were popular. The stone was hauled in a neighboring frolic, and the contract price for building the school was $100. The schoolhouse is located on Dean Road in Knowlton Township.

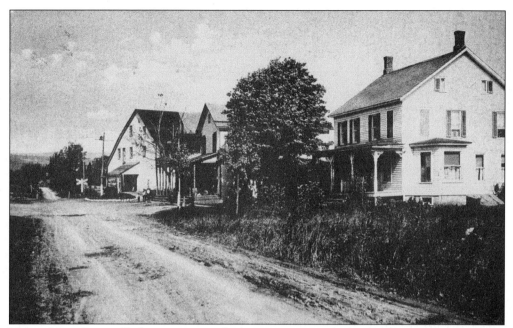

This is Main Street, Vail, sometime in the late 1890s. Long before being Vail, this place was called Molasses Junction. That was because Samuel Yetter, who lived during the 1840s in the stone house still standing by the culvert, was conned by a couple of sharpsters into believing he could make molasses out of rhubarb, and the naive yokel sank a lot of money into the project before he found out it was a fraud.

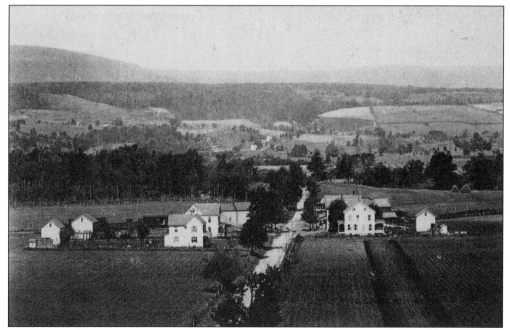

This is a bird's-eye view of Vail looking toward Blue Mountain Ridge. Little has changed since this photograph was taken.

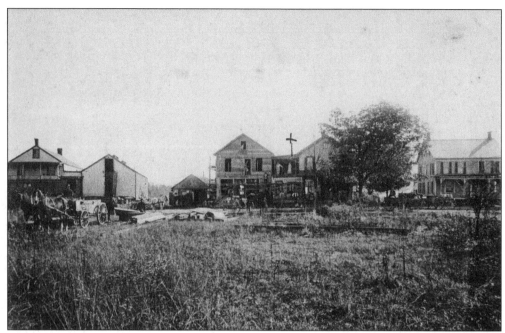

The business section of Vail proved a great convenience to those who went to Bailey's Creamery, which formed the nucleus of this town. In the 1890s, the creamery was the largest on the rail line. It delivered all of 40 cans of milk a day.

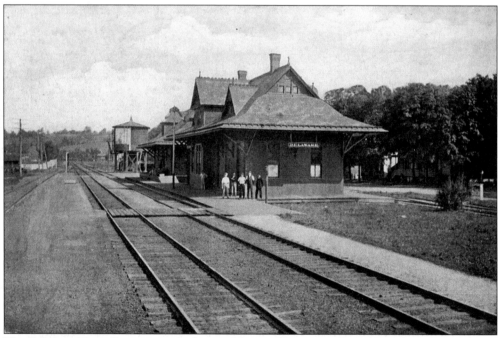

The Delaware Train Station was the heart of this small town, as the rail lines brought goods and people to town on a daily basis. This was the junction point of the New York, Susquehanna and Western and the Delaware, Lackawanna and Western Railroads.

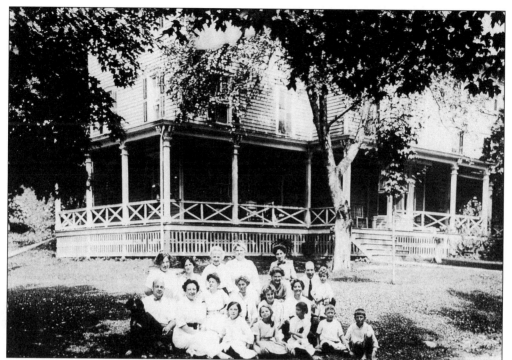

In the late 1800s, James Hutchinson operated his mill on a day and night shift. He eventually became blind, but felt hiring a second operator was unaffordable. At this time his wife, Mary, started a boarding house called the Delawanna. They accommodated 50 or so guests during the summer season.

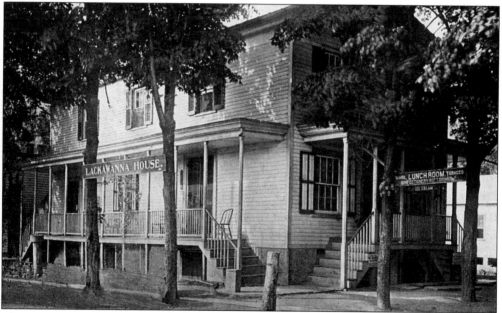

The corner building across from Clinton Street and Railroad Avenue was built in 1860 by George G. Flummerfelt and was called the Lackawanna House. It contained the restaurant of Charles Cool. In later years, it became an antique business.

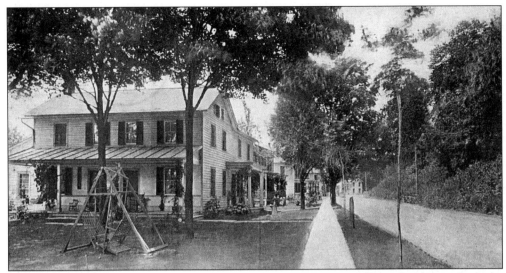

The Delaware Presbyterian Parsonage on Valley Street, originally a farmhouse built by Cornelius Albertson in 1820, was purchased by John I. Blair to build the railroad. Being of a generous nature, Blair later donated the building for use as the Presbyterian parsonage. According to the methods of the times, the walls were filled with straw and wet mud and allowed to harden. This formula was obviously sound since the building still stands today.

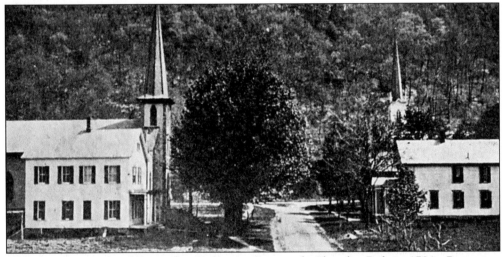

The church on the left is the Delaware Episcopal Church. Before 1784, Protestant Episcopalians held meetings at the home of Robert Allison. In the year 1784, the first church was built near the river below Delaware. In 1841, a new stone church was built near the old one. However, a spark from a DL&W Locomotive started a fire which burned the church to the ground on June 27, 1866. In 1869, the present church was built near the railroad tracks at a cost of $6,000. In 1881, it had 35 members. Today, services are no longer held in the church.

On the right is the Delaware Presbyterian Church, organized in the village of Delaware by the authority of the Newton Presbyterian on June 7, 1871. It was originally a mission of the Knowlton Church and was a result of the labors of Mr. William H. Hemingway and Mr. John M. Burd. The church was built in 1875. Presiding at the dedication services, John I. Blair revealed his usual generosity when he presented the parsonage house and the lot on which the church stands.

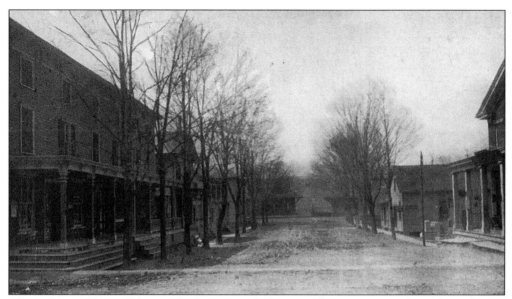

This is Main Street, Delaware, looking toward what is today Route 46. The Delaware Train Station was located at the end of the street.

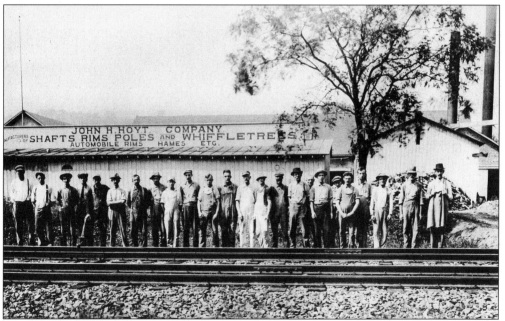

Buggy Shafts	Carriage Rims
$33.75 to $37.00 half finished	$2.12 to $13.08 hickory
$39.40 to $44.10 finished	$3.38 to $23.00 oak

These prices are quoted from the Hoyt Bending Works' 1914 brochure. Other products manufactured were automobile rims and whittle trees (the pivoted crossbar at the front of wagons to which harnesses were attached). At the onset of war, business turned to making walnut and mahogany gunstocks for Enfield and Springfield rifles. The rear of the building was converted for canning tomatoes under the management of Hoyt and Albertson. The building was later dismantled by Hoyt and Son and was used for building homes in Easton, Pennsylvania.

In 1860, John I. Blair built the brick residence and store at Delaware Station. Many successful proprietors occupied this building, which also housed the Delaware Post Office.

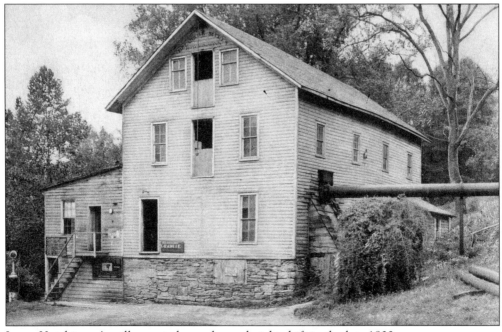

James Hutchinson's mill operated on a day and night shift in the late 1800s.

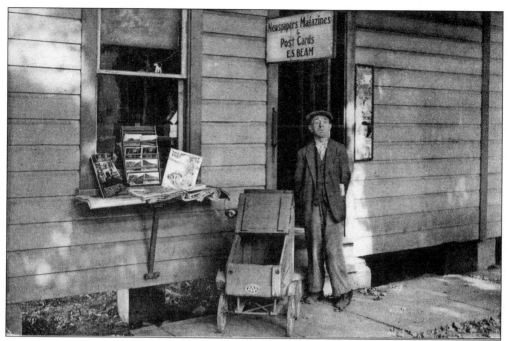

E.S. Bean, of Bean's News Agency, was an enterprising businessman who sold newspapers, magazines, and postcards sometime in the early 1940s.

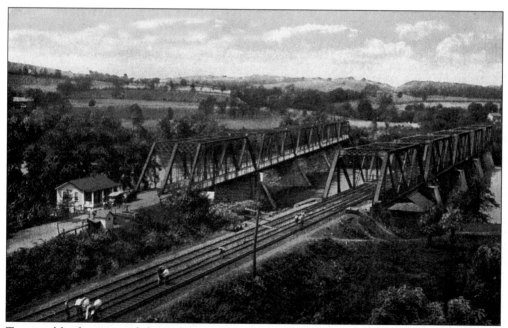

Two steel bridges crossed the Delaware River—one was for motor traffic, the other for trains. The toll bridge was owned by Rev. Darlington. Later the bridge was taken over by the Delaware River Bridge Commission and made into a toll fare bridge.

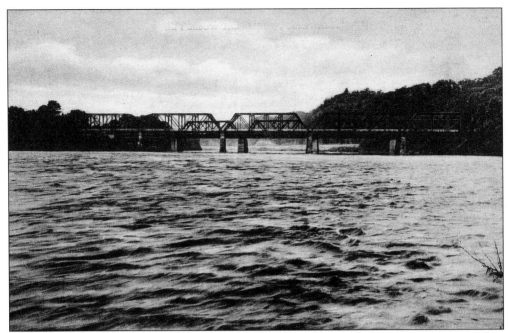

Looking up the Delaware River, the rift below the two steel bridges can be seen. These bridges were later taken down and replaced by the present bridge, located further north in Portland, Pennsylvania.

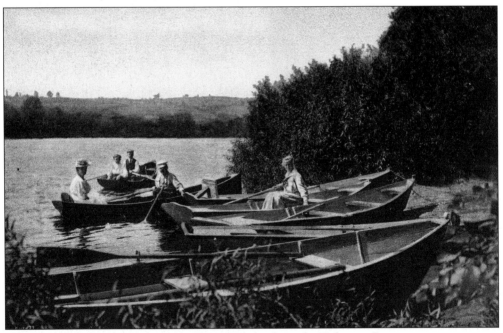

Summer visitors enjoyed boating at Spring Brook, along the Delaware River.

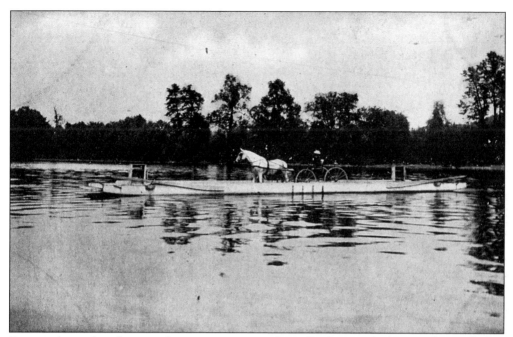

Farmers drove their horse and wagon teams onto large flat boats, which were then pulled or poled across the Delaware River by Myers Ferry. A cable reaching from shore to shore kept the boats from being swept down stream. The ferry at Delaware remained in use until the iron bridge was built.

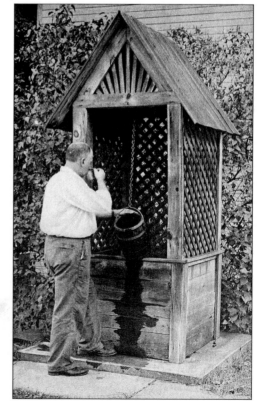

This is the old water hole at the center of Delaware. I wonder how many stories that old bucket could tell?

The Willow Lake House, Delaware, held a Children's Day and gave them a hayride around town.

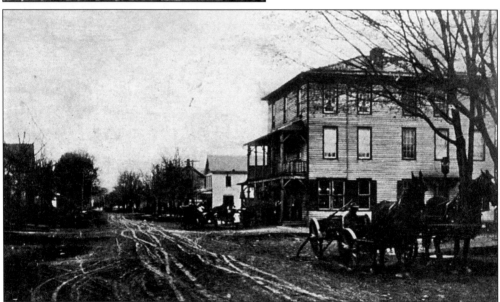

In 1813, Hamill's Store on Main Street, a three-story building, was put up by Herman Geisse. It is believed a cigar factory was operated on the third floor. Green and Creamer ran a store on the lower floor in 1837. The business eventually passed on to other proprietors—Davenport and Snyder, Albertson and Davison, Charles Mann, and Alois Dascoe (under whose ownership it burned down).

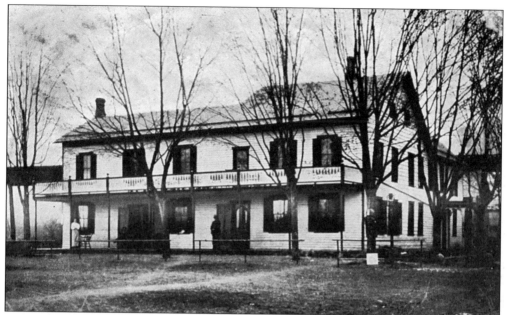

The Columbia Hotel was built in 1828 by John J. Van Kirk, who served as sheriff from 1851 to 1854. To the dismay of many seasonal tourists who stayed at this popular resort, the Columbia Hotel was destroyed by fire on February 28, 1963.

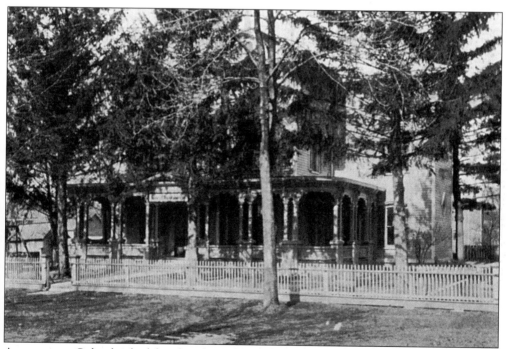

At one time, Columbia had four hotels, each of which prospered well as riverside resorts. The River View House was located at the corner of Green and Washington Streets.

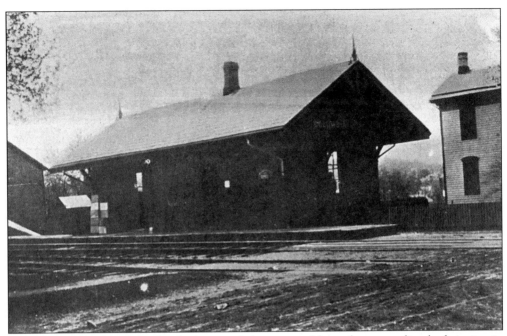

The railway depot at Columbia had many daily stops and kept the town alive by bringing in visitors to the local river hotels.

Here is a view from the railway depot. It is understandable why people came to visit this quiet little town.

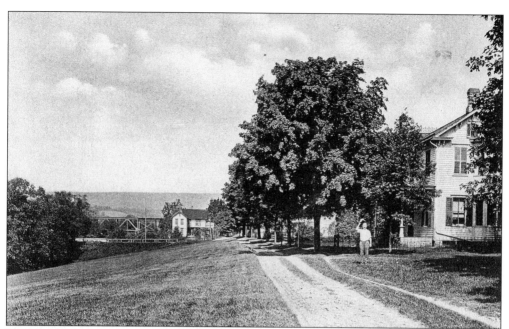

Washington Street runs along the Delaware River.

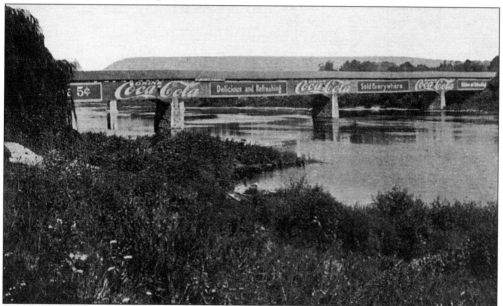

The covered bridge in Columbia was built in January 1869 by the Charles, Kellogg and Maurice Company. Two earlier and unsuccessful attempts were made by Francis Myerhoff in 1816 and the Columbia and Delaware Bridge Company in 1839. The Burr Truss Bridge, 775 feet long and 18 feet wide, was first traveled by Mrs. William Sandt in her sleigh. Until 1926, various tolls were collected from all who crossed, with the exception of baby carriages, which were free. The structure withstood extensive damage caused by the windstorm in 1929 and the floods of 1903 and 1936. In 1955, it was the longest wooden covered bridge and the last to span the Delaware. Many people can remember Hurricane Diane and the highest waters ever recorded on the Delaware, which finally took this famous landmark.

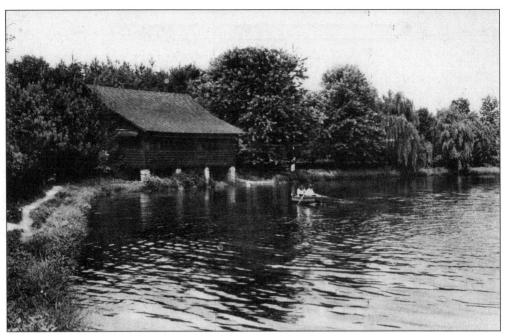

Columbia was also known for its many camps on the Delaware River and fine local lakes. Shown is the dining hall and lake at what was known as Camp Pinelock.

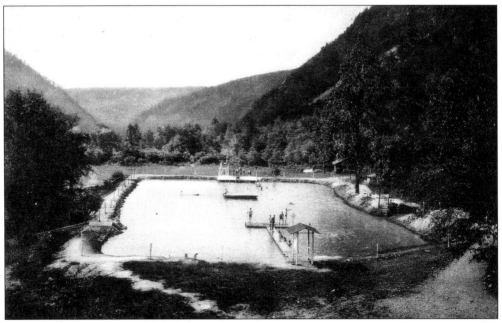

Another camp was Camp Weygadt at the foothills of the Blue Mountains. The size of this swimming pool was 210 by 90 feet.

Centerville is a small hamlet in the southwest part of the township. How Centerville came to be is as much of a conundrum to the present generation as it probably was to the first. For many years, previous to the cutting off of Blairstown and a part of Hope Townships from Knowlton, this was the center of town business and town meetings were held at this point. Take a ride and you can still see this same spot today.

To the right you can see the home of Peter Blair, the first postmaster in Centerville. He was also the second tavern keeper at this location. In the rear of his tavern was his little store, where he exchanged codfish and molasses, sugar and rum, snuff, tobacco, and calico for cash as the surrounding farmers had to dispose of it. At the time, Mr. Blair was postmaster—the mail was carried on horseback from Columbia to Hackettstown, and the postage on a single letter was 24¢.

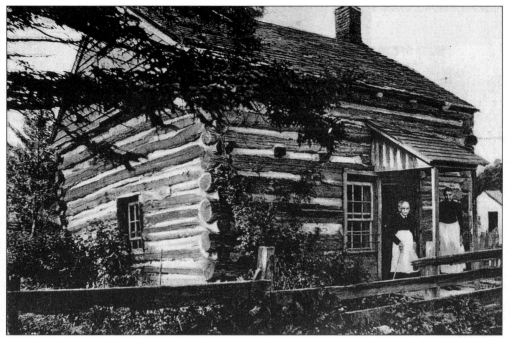

Here we see Mrs. Emmaline Blackford and her daughter in front of their log cabin, located near Newbaker's Corner and Birch Ridge Road in Hardwick Township.

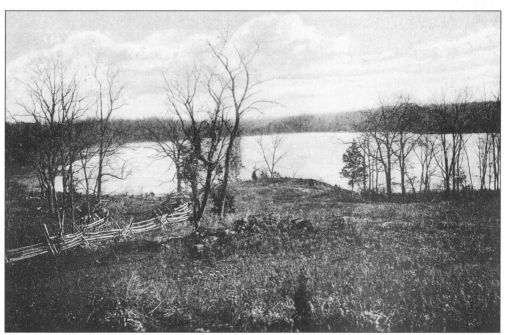

White Lake, in Hardwick Township, is known to have the only pure shell marl deposit in the United States. The marl deposit is 104 acres with an average depth of 22 feet. Marl is said to have been formed by the disintegration of millions of minute shells and mollusks. It was used to make cement by the Warren Portland Cement Company.

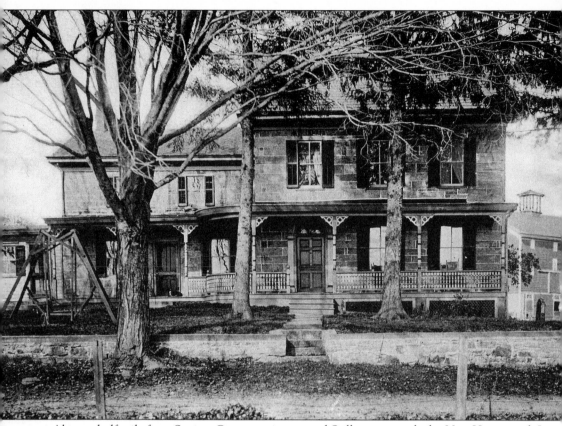

About a half mile from Squiers Corner, going toward Stillwater, stands the Vass Homestead. It began as a farm in 1802, with 548 acres.